Then & Now
SCITUATE

THE SCITUATE HISTORICAL SOCIETY

INCORPORATED 1917

THE CUDWORTH HOUSE
HOME OF THE SOCIETY

THEN & NOW
SCITUATE

Scituate Historical Society

ARCADIA
PUBLISHING

Published by Arcadia Publishing
Charleston SC, Chicago IL, Portsmouth NH, San Francisco CA

Printed in the United States of America

Library of Congress Catalog Card Number: 2002106587

For all general information contact Arcadia Publishing at:
Telephone 843-853-2070
Fax 843-853-0044
E-mail sales@arcadiapublishing.com
For customer service and orders:
Toll-Free 1-888-313-2665

Visit us on the Internet at www.arcadiapublishing.com

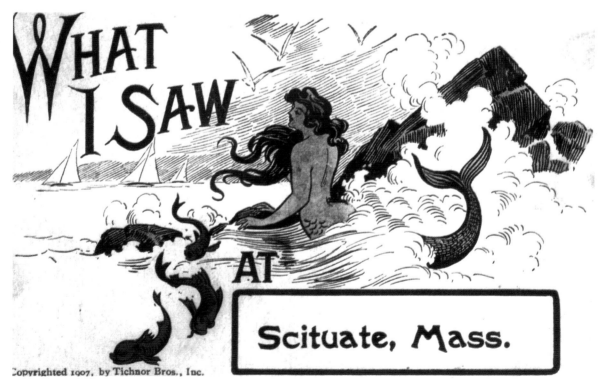

There was indeed a lot to see in Scituate at the beginning of the 20th century.

CONTENTS

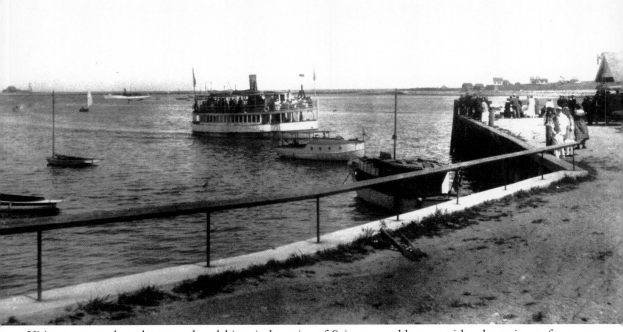

Visitors attracted to the natural and historic beauties of Scituate could come either by train or, for a more scenic trip, by boat.

INTRODUCTION

The spring sun had only begun to warm the frigid waters of Scituate Harbor when the small steamboat, passing by the old lighthouse, announced its approach with a shrill cry of its whistle. The holiday weekend had ensured a full complement of passengers when it pulled away from India Wharf in Boston Harbor earlier that morning. Now, as the vessel eased its way toward the town dock, passengers in their Easter finery crowded the deck railing in impatient readiness to go ashore.

Among the lively assembly was a bespectacled young man with thinning hair who hours earlier left his home in Wellesley Hills to see what he had only read about in the Boston weeklies. Mowry Kingsbury had caught the train to Boston and secured a ticket to what in 1899 were the growing seaside communities that made up the South Shore of Boston. At his place of work as paymaster of the Dennison Manufacturing Company, Kingsbury had heard coworkers speak of the almost hidden towns along the coast that beckoned visitors to sail their waters, explore their country lanes, and admire their rustic old houses and quaint villages.

Standing on the wharf, Kingsbury glanced toward what he would soon learn was Jericho Beach. Dotting the shore were several mossy shanties punctuated by stacks of lobster pots. Seagulls hovered in the air, raising and dropping mussel shells. He stepped off the wharf and gazed down the tree-lined avenue that was the heart of the harbor village. Wagons and carriages rolled by as pedestrians crossed over or avoided the mud by staying along the boardwalks. Stately sea captains' homes were a sharp contrast to the bustle of the storefronts across the way.

When Kingsbury returned to Wellesley Hills that evening, he put into verse all that he had experienced that day. A lover of the written word, he found in Scituate a subject that would remain with him the rest of his life. Shortly thereafter, he became a resident, building a cottage on Jericho Beach that survives today. Through life's ups and downs he would continue to write about what he called the "little village by the deep blue sea."

What caught Mowry Kingsbury's attention on that spring morning in 1899 thrives today, as the charm of a New England coastal community still enchants visitors from all over. As we will see in the chapters to come, Scituate, especially at the beginning of the 20th century, was a town undergoing significant change from, as author John Stilgoe suggests, "a place in which old habits and old things endured essentially because they could not be replaced," to a community revived from outside influences, most notably a growing summer community beginning in the years following the Civil War. In addition to the discovery of Scituate as a summer retreat, the last quarter of the 19th century brought the railroad and individuality in the form of Wall Street financier Thomas W. Lawson and his Dreamwold estate. Today, Lawson's legacy continues as strong as ever. Now, let us take a look at Scituate then, and Scituate now.

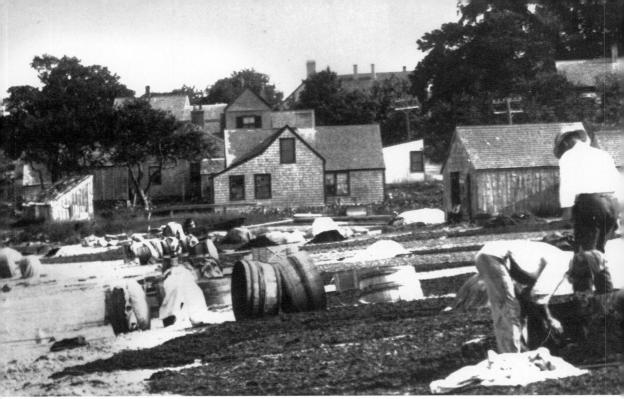

Mowry Kingsbury was forever entranced by the scenes along the Scituate shoreline.

During the summer of 1901, the author of a *Hull Beacon* article entitled "Summer Saunterings" had the following to say about a recent visit to his neighbors to the south:

"Scituate is a very pretty town, liberally endowed by nature with many attractions. It has several villages, an extensive water front and many fine beaches. The principal village known as The Harbor is unique in its way with just enough of the old salt flavor to remind one that it was in days gone by somewhat of a seaport town. In the past it was quite a port for fisherman, but like Hingham, Cohasset, and other towns along the coast, its glory in that line has departed."

This bittersweet observation made just over 100 years ago correctly defines what was one of the most prosperous seaports between Boston and New Bedford in the 200-year period between 1650 and 1850. Near the present-day town pier in

Chapter 1

OLD SCITUATE BY THE SEA

the mid–1600s, Will James established a dock and warehouse. Plentiful hardwood allowed shipyards to operate on location, turning out coastal trading and fishing vessels. By 1700, a substantial fleet was

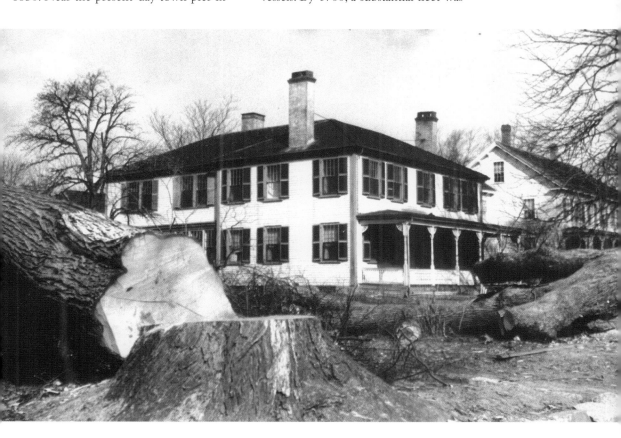

operating out of Scituate Harbor. To support these seafaring ventures, shipwrights, chandlers, coopers, blacksmiths, and sailmakers set up shop along what is today Front Street and the heights. In the years during the American Revolution and the War of 1812, Scituate experienced a decline in trade, as did all New England ports as the result of the hostilities. In the early 19th century, competition from other ports, especially deepwater harbors, caused a decline in the fishery and shipbuilding industries. In 1850, Scituate's fishing fleet brought home 2,500 barrels of mackerel, a sharp contrast to the 15,000 barrels brought into port in 1828. By the end of the Civil War, the heyday of the harbor, when successful maritime family names such as Dunbar, Otis, Webb, Bates, Beal, Waterman, Curtis, and Cole graced many a weathered signboard, was becoming a distant memory.

Fortunately, the discovery of Scituate as a summer retreat brought prosperity back to the harbor in the form of George F. Welch, who responded to the building boom of summer cottages along the waterfront by establishing his lumber and supply business in 1871. In the ensuing years, lumber schooners and pleasure crafts replaced the coastal traders and fishing "smacks" of earlier days. The arrival of the railroad and excursion vessels during the summer months attracted out-of-towners who admired the stately homes of former sea captains along the west side of Front Street and shopped in the stores on the east side. Throughout the 20th century, the character of the harbor underwent significant changes, not always for the better. As a commercial center, it was only to be expected that change would come, as we see in the dramatic 1938 photograph on the previous page. There are still residents today who recall the beautiful empire elms that to many locals defined Front Street. They were believed to have been planted in the late 1840s by Front Street resident Capt. Ezekial Jones, who brought the saplings home from a voyage to Nova Scotia. Over the years, these trees grew to enormous heights, creating a cathedral effect along Front Street in the winter and summer. Their untimely end came when property owners along the residential west side wanted to develop storefronts off existing homes in addition to establishing new commercial ventures. Despite howls of protest from townspeople and a special town meeting, the trees came down, as would also the twin-chimney, Federalist-style home that once belonged to the Jones family and later to the Chubbuck family. As a result, it would be years before some members on opposing sides of the controversy would speak to each other again. In more than a few cases, they never did.

The early residents of Scituate knew right away that their treasured spot on the South Shore needed to be protected from overexposure to the outside world. In 1667, the town passed a law prohibiting any resident from "entertaining a stranger" in their home overnight, under penalty of fine and remonstrance from the town fathers. Two hundred years later, however, when the industrial revolution fostered in the idea of vacationing for the American public, Scituate became the perfect getaway spot. Those same industrious families that once fished and traded now opened boardinghouses, eating establishments, and boat-for-hire stands, catering to the outsiders their ancestors had tried to exclude for two centuries. Small hotels like the Stanley House and the Merrymount House, shown here anchoring the north end of Front Street,

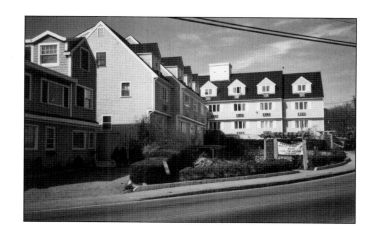

welcomed visitors all throughout the summer season. Today, on that same spot, the staff of the Inn at Scituate Harbor, formerly known as the Clipper Ship Motor Lodge, carries on the tradition.

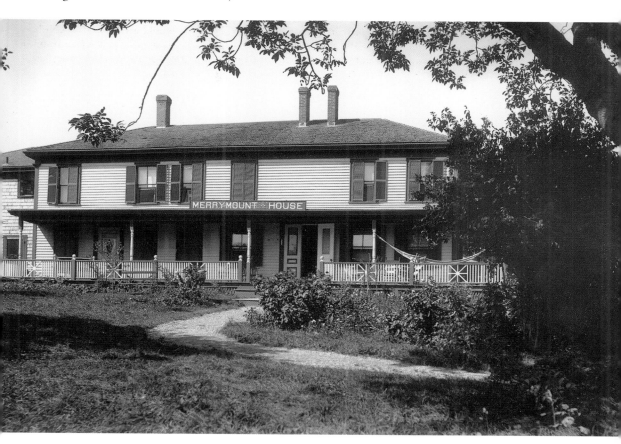

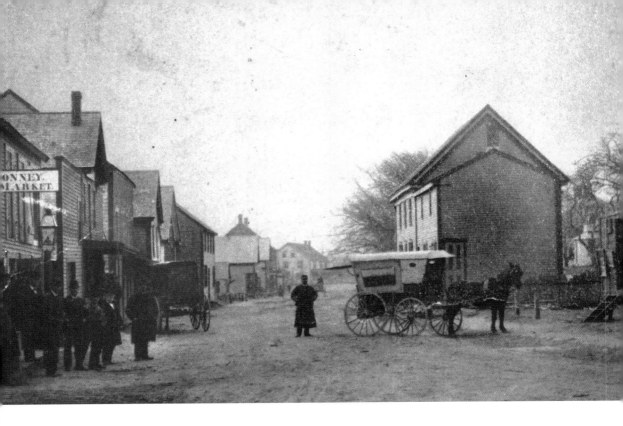

An unknown hand scrawled on the back of this photograph that this Front Street image was taken on a Saturday morning in 1885. Studying the photograph, one can almost smell the mud and manure of unpaved Dock Street, mingled with the odor of wood smoke from countless fires from homes and shops. On the left, one can make out the signboard for Edward Bonney's fish market. The site is now occupied by a restaurant. On the right is the store and post office of William Paley-Allen. In later years, the store was owned by Charles Frye.

What is now the parking lot for T.K. O'Malleys restaurant was once the location of one of Scituate's finest homes. In 1785, Jessie Dunbar (1761–1836), a successful merchant, married Sally Witherel of Plymouth. As a wedding gift, he presented his bride with a mansion of her own. Dunbar hired only the best housewrights and detailed the interior with exotic wood that ships—of which he owned several shares—brought from the far reaches of the globe. Every room in the mansion was furnished according to the European styles of the day. Dunbar enjoyed a long and prosperous career in maritime shipping. Across the street was the site of Dunbar's wharf and warehouse where many a long voyage began and ended. Upon Jessie's death in 1836, the mansion passed to his daughter Sarah and her husband, Dr. Francis Thomas. The home remained in the Dunbar family until purchased by fish market owner Edward Bonney in the late 1800s. For reasons unknown, the house was vacated in the 1930s, and plans for demolition followed. The house was dismantled in the spring of 1938, and some of the

beams and beautiful woodwork were purchased by townspeople to incorporate into their own homes. An exciting find was made during the dismantling of the dwelling when a concealed passageway was discovered behind one of the home's many fireplaces. The tunnel is believed to have led under Front Street, coming out at what was Dunbar's wharf. This discovery is supported by an earlier incident in which, during roadwork on Front Street, a trench partially collapsed, revealing a section of a brick-lined tunnel that was dismissed as a discontinued sewer line.

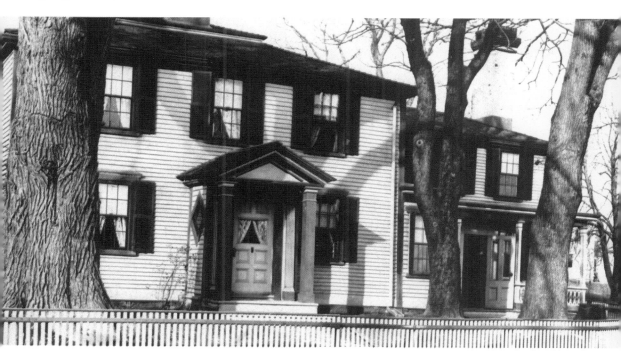

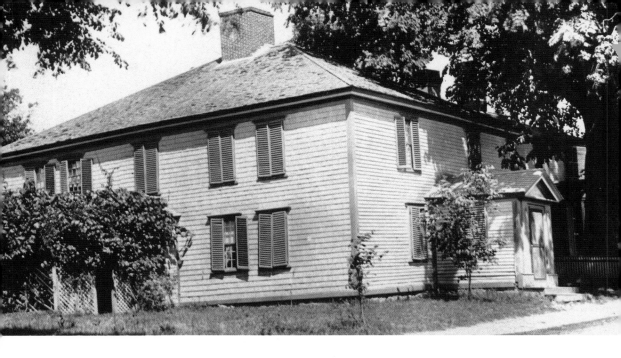

On the southern side of the Dunbar property stood the ancient home of Capt. Stephen Otis (1661–1733). Shortly after purchasing the warehouse of Will James, Otis built this hip-roof-style dwelling with a large central chimney in 1697. Upon the death of Otis, the house passed between several members of the family. It is believed that the house became a tavern by the 1760s and that patriot meetings convened here during the American Revolution. It is also believed that the last meeting of the town's founders, the Conihasset Partners, was held here in 1767. In the late 18th century, the house was sold to Capt. James Little, who lived there until

his death in 1803. In 1821, Gideon Young purchased the property and established Young's Tavern, which became a stop on the Boston-to-Sandwich stagecoach line. In the mid-1800s, storeowner William Paley-Allen, whose wife, Abigail, was the maternal granddaughter of Captain Little, purchased the house and lived there for many years. In 1921, the Cushing Chapter of the Daughters of the American Revolution set out to publish the now classic book *Old Scituate*. Scituate resident Col. C. Wellington Furlong served as photographer for the project, journeying around town and documenting Scituate's many ancient dwellings. When he visited the old Otis house, he marveled at the hand-hewn ceiling beams and massive fireplaces. He was amazed to find the old tavern taproom still intact and the steep, narrow staircases that led to the upstairs chambers. This photograph was taken by Furlong during that visit. Despite its rustic charm, the ancient home, built four years after the conclusion of the notorious Salem Witch Trials, would fall to the wrecking ball in 1927. Near that site, a similar Otis house today serves as Wiggy's Cove Gift Shop.

The arrival and subsequent success of George F. Welch's lumber company and store in 1879 marked a turning point in the economic decline of the harbor village. The discovery of Scituate as a summer retreat created a building boom along the shoreline. Between 1871 and 1876, the number of dwellings increased by 18 percent. This boom was constituted largely by cottages, boardinghouses, and hotels. A shrewd businessman, Welch was determined that supply should meet demand, as lumber schooners sailed into the harbor loaded with thousands of hemlock and spruce laths, in addition to household items such as dining sets, parlor stoves, silverware, and assorted hardware. The ever observant Floretta Vining had this to say about the Welch Company in 1901: "The first object that met our view was the establishment of George F. Welch, as fine a store as I ever saw in the country, with a stock unequaled in a town so far from Boston, and things up to date. I was simply amazed. The paint stock alone filled one side of the building.

Handsome furniture and every kind of garden tools, kitchen and dining room ware of the best quality." On the west side across Front Street was the store and post office owned and operated by William Paley-Allen. Upon Paley-Allen's death, the business was run by relative Charles F. Frye. Among the items found in the Frye store was crockery that depicted local scenes, such as Old Scituate Light and the Old Oaken Bucket Homestead. These much sought after items can still be found in Scituate homes today.

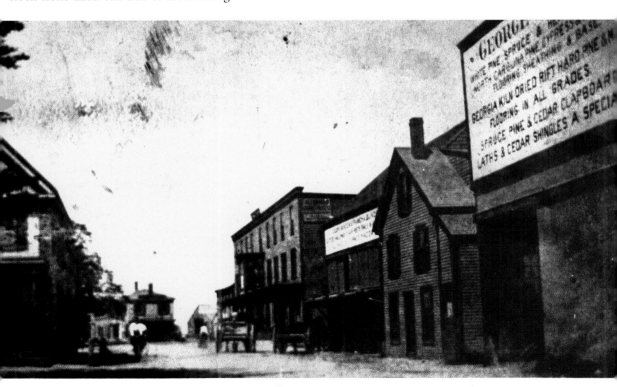

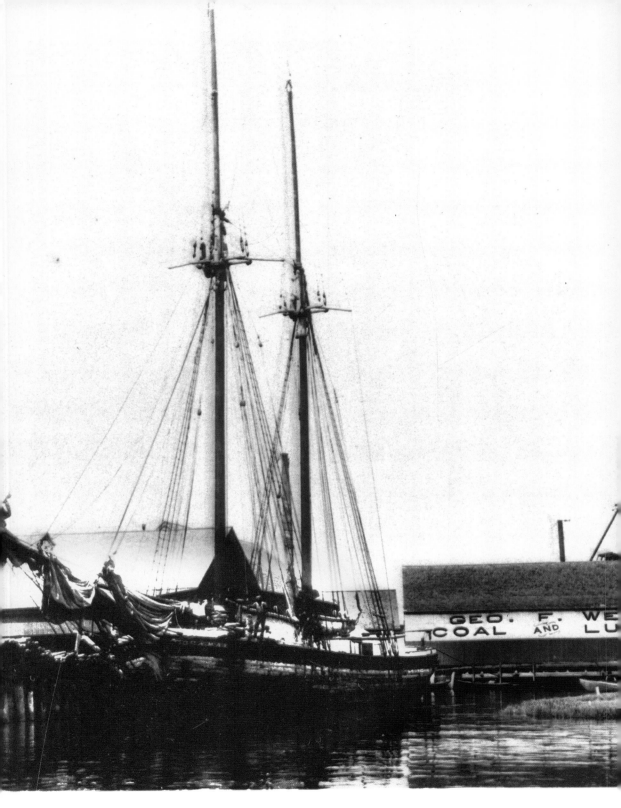

It has been a long time since the last lumber schooner sailed into Scituate Harbor under the Welch Company banner, but the legacy of Scituate's most up-to-date merchant lives on through the gift shop that even today bears his name. The storefront has undergone several changes over the years, including a 1950s fire that destroyed the top floor of the building, a spectacle viewed by hundreds of residents who could see the smoke from their homes.

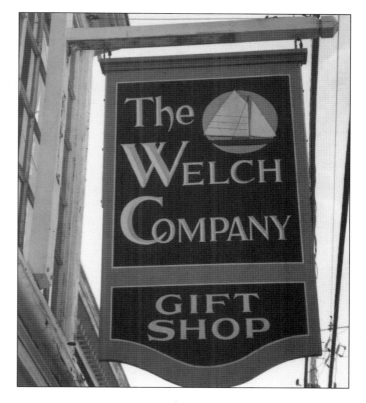

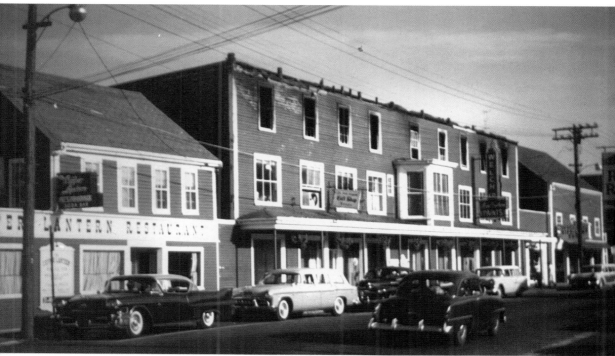

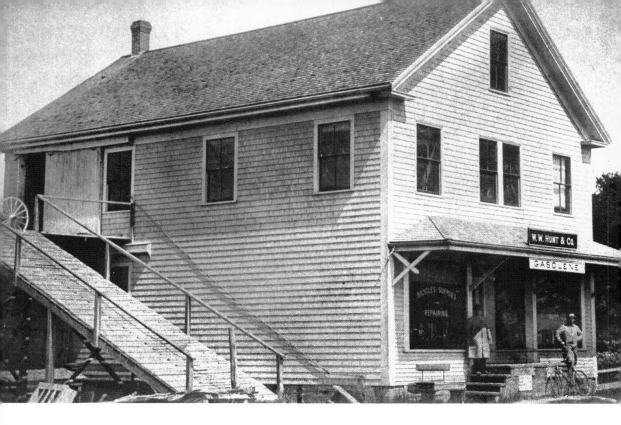

Today, customers pull in to pick up pizza and submarine sandwiches at the old Harney building. More than 100 years ago, W.W. Hunt & Son rolled out horse carriages, as can be seen by the ramp to the left of the building. Additions to the structure over the years included the Town Pump, Corson's Town Cleaners, the Children's Shop, Scituate Cleaners, and the Rockland Savings Bank.

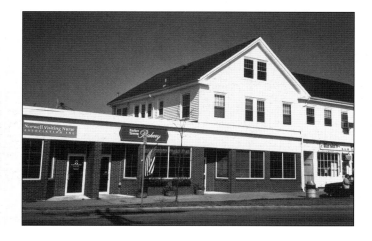

Amid all the changes that have taken place in the harbor village, this building has somehow survived the onslaught of time to be regarded as a true Scituate landmark. In 1910, this Bavarian-style structure served as a soda and confection shop run by Charles Stenbeck. Gone were the days of the ship chandler, as residents and visitors with disposable incomes found free time for ice cream, soda, and sour balls. Over the years, a series of owners, menus, and names ensued: the Candy Cane, Brass Lantern, Jackies, and many more along the way.

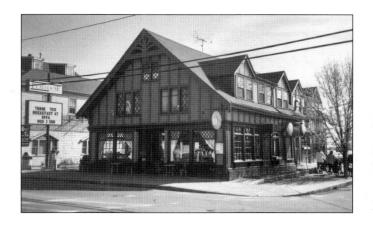

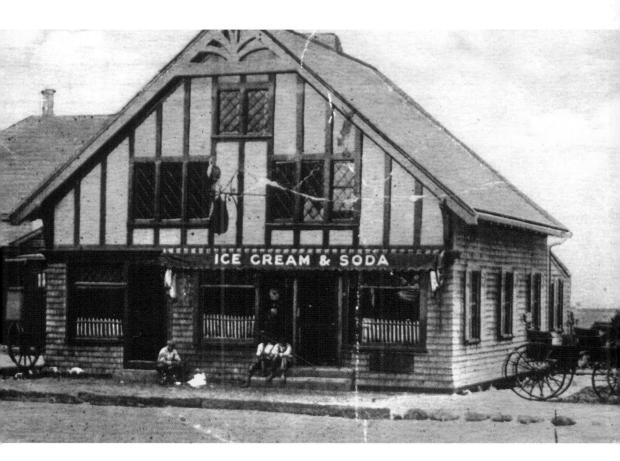

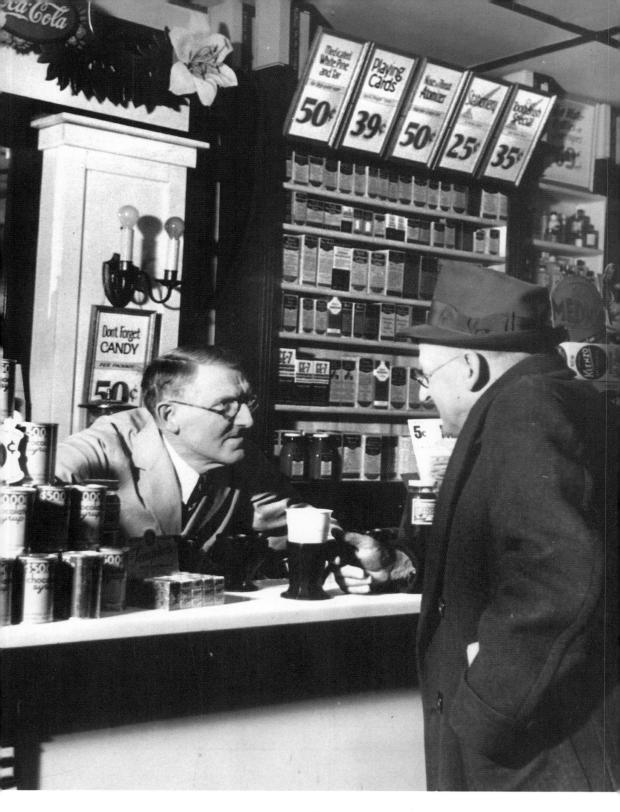

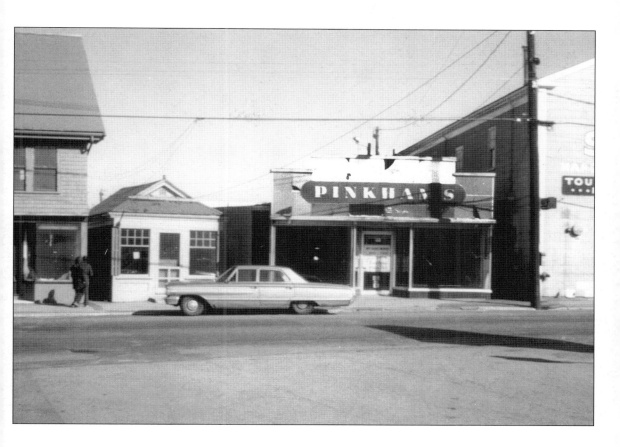

The location in which Scituate Federal Savings Bank now stands was once where castor oil and hot-water bottles were bought and sold. Through this wonderfully informal photograph taken inside Pinkham's Drug Store in 1938 (opposite), we are brought back in time to sniff the scent of Dill's Best and the Smith Brothers.

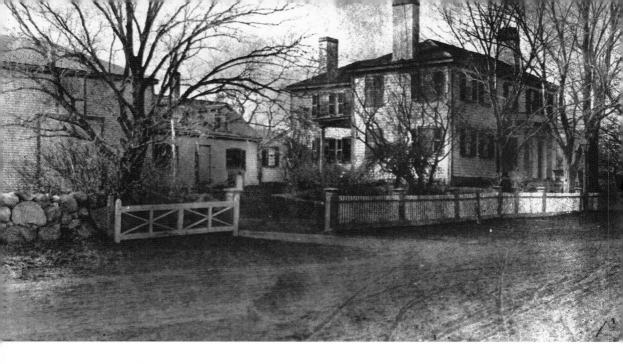

What has long been the rectory at St. Mary's of the Nativity Church was once the home of one of Scituate's successful master mariners. Capt. Seth Webb (1797–1870) came from a long line of seafaring men. While still in his twenties, he became master of several vessels that were involved in coastal trading as well as transatlantic voyages. In 1820, he married Eliza Dunbar, daughter of Squire Jesse Dunbar, thus joining two financially successful and powerful maritime families. As his father-in-law had done 35 years earlier, Webb presented

his bride with a mansion by the sea for her own. The family continued to prosper. Their son, Seth Jr., grew up to set a different course for himself. A Harvard graduate, he chose not to follow the sea but instead entered into a very successful law practice in Boston. On the eve of the Civil War, the junior Webb moved at the top of the inner circle of Massachusetts politics, forging a strong friendship with Gov. John A. Andrew. It was Andrew who recommended to Pres. Abraham Lincoln that Webb be appointed to the post of minister to Haiti. Seth Jr. held the post for less than two years as his health went into decline. Returning home in 1863, he died in the care of his family at his father's harbor mansion at the age of 41. In this photograph, taken in the 1870s, we see that the original location of the mansion was closer to present-day First Parish Road in front of where the present church is located. When the Catholic archdiocese purchased the property as a rectory, the original St. Mary's on Meetinghouse Lane was still in use. Later, with plans to build a new church under way, the mansion was moved back to its present location.

As early as the 17th century, ships began running into trouble along the coast of Scituate, starting with North River pilot Anthony Collamore's vessel that went to pieces in 1693 on the ledge off Minot that now bears his name. Shipwrecks necessitated the construction of lighthouses and eventually lifesaving stations, tying Scituate deeply into the history of the U.S. Coast Guard. From time to time, mysterious and unexplained things have come ashore at Scituate, such as the 1970 arrival of the Scituate Sea Monster. Overnight on March 16 and 17, 1956, the Italian freighter *Etrusco*, seen here, grounded on Cedar Point alongside Scituate Light, instantly becoming one of the most successful short-term sightseeing attractions the South Shore has ever

ALONG THE

WATER'S EDGE

known. Only a select few, however, watched it leave on Thanksgiving Day of that year. After three centuries of surprises, Scituate residents have learned never to take their eyes off the sea.

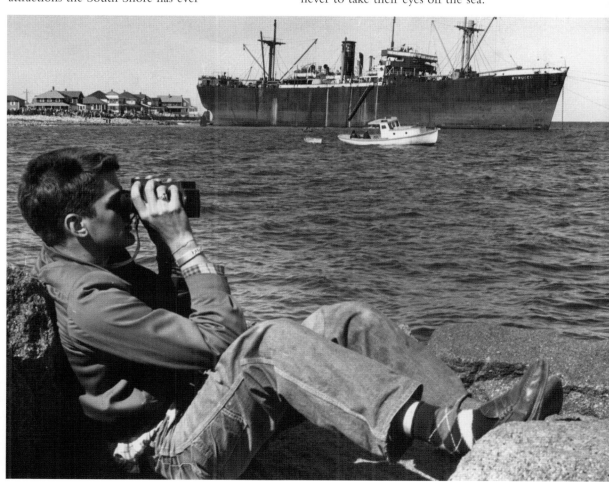

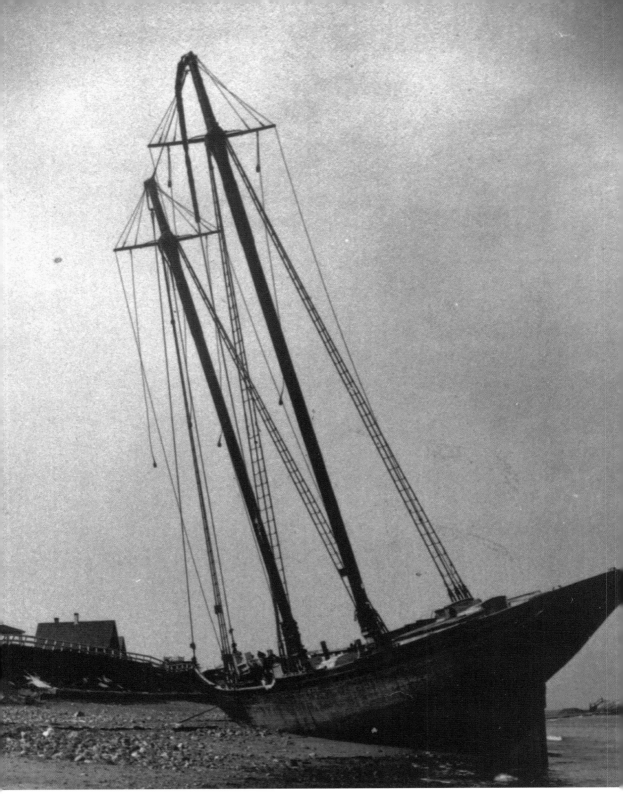

As long as there have been shipwrecks along the Scituate shore, there have been people there to help collect the cargo that inevitably washed up on the beach. Some shipwrecks, such as the *Matiana,* were more convenient than others—because it was left high and dry, salvage operations were simple. Other ships, however, left their goods—and sometimes their passengers—on the ocean floor. From time to time, local divers are lucky enough to make a startling find. Tom Mulloy, while diving on the 1853 wreck of the *Forest Queen* off Peggotty Beach in the early 1990s, discovered a solid, 73-pound bar of silver marked with the stamp of the Chinese emperor. Irish mosser Daniel Ward, who had the original salvage rights to the ship, told his friends that he was finding nothing but lead bars on the wreck. The manifest, however, listed 12 tons of silver as being among the cargo, and Ward went from living in a shack on the beach to moving into the biggest house in Scituate shortly after completing his work on the wreck.

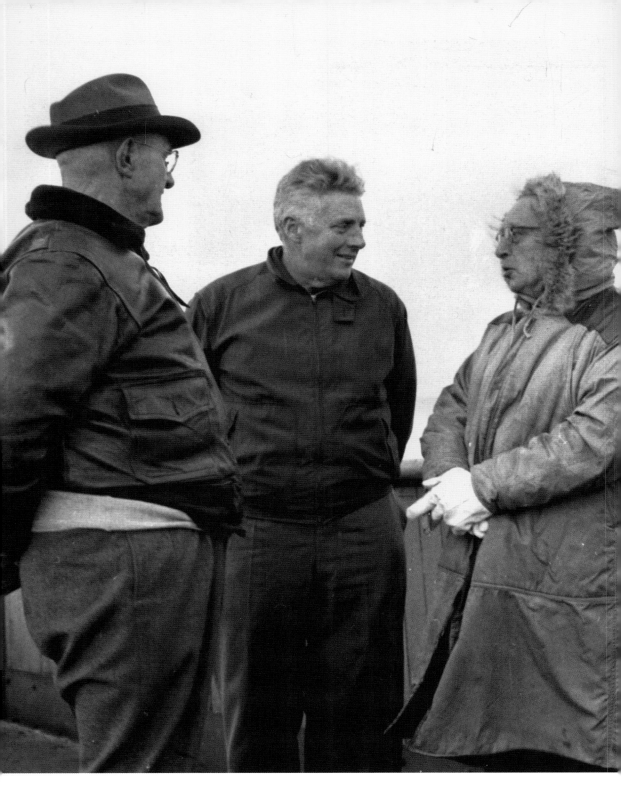

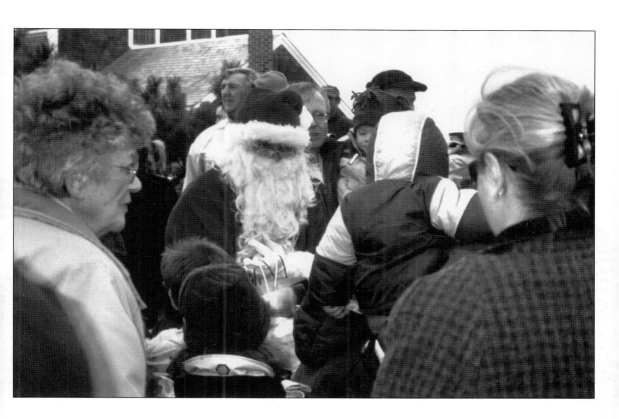

Oue man who learned to keep his eyes on the sea, Edward Rowe Snow, could always be counted on to
be around whenever something like the *Etrusco* grounding took place. From his early days as a high-
school teacher to his everlasting fame as the undisputed king of Boston Harbor historians, Snow wrote books
and newspaper articles, lectured, led tours, and spoke over the radio to hundreds of thousands of interested
Massachusetts residents on pirates, shipwrecks, storms, buried treasure, and other tales of the sea. A resident
of Marshfield, Snow lectured at Scituate's Grand Army Hall and was heavily involved with the story of the
Etrusco. One of his most enduring legacies, however, may be the continuation of the tradition of the "Flying
Santa of the Lighthouses," a role he played for more than 40 years. In 2001, Flying Santa Dave Waldrip, one
of the many men who don the red suit each year, landed on Cedar Point by helicopter and brought joy to
the gathered children.

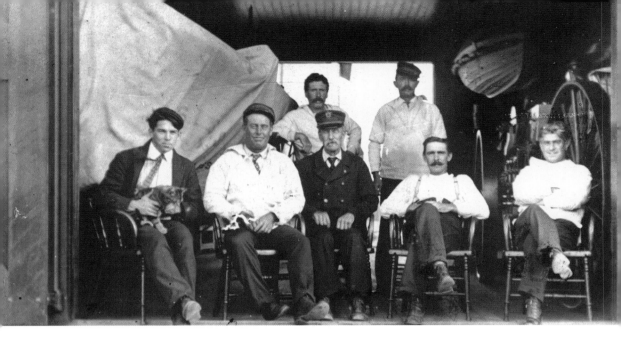

A late-18th-century shipwreck disaster on Lovell's Island in Boston Harbor spurred the formation of the country's first shore-based lifesaving system, operated by the Massachusetts Humane Society and loosely based on England's Royal Humane Society. Although eventually known for its lifeboat rescues and heroes, the organization first gathered for medical purposes, hoping to find new ways to restore the "apparently drowned." As its first act toward its lifesaving goals, the society built three houses of refuge, one of which was at the base of Third Cliff in Scituate, in 1787. In 1848, the federal government patterned its new U.S. Life-Saving Service on the Massachusetts model, by then a system of lifeboat and mortar stations as well as houses of refuge. By 1886, Scituate boasted two federal crews, one stationed at Humarock and one at North Scituate. In 1915, the Life-Saving Service became part of the new U.S. Coast Guard, using the old lifesaving stations until a separate structure on First Cliff was built during the Great Depression. In 2001, the Coast Guard raised the American flag over their new station on Cole Parkway.

The Fourth Cliff station came to a sad end when it burned down in 1919. One of the earliest lifesaving structures on the South Shore, it was built in 1879 as an 1876-type station (many of the early building plans were named for the year in which they were developed). Keeper Frederick Stanley led the station's crew for many years, watching them patrol south to the mouth of the North River off Rexhame Beach in Marshfield, and north across the barrier beach that spanned Third and Fourth Cliffs, all the way to Scituate Harbor. When the Portland Gale of November 1898 destroyed that barrier beach and closed the old mouth of the river, Stanley's crew was isolated from the rest of Scituate. Longtime surfman Matthew Hoar, pictured below, took over for the retired Stanley just before the station burned down. In September 2001, Sen. Robert L. Hedlund (left), Rep. Frank Hynes (center), and Humarock Beach Improvement Association president Russell

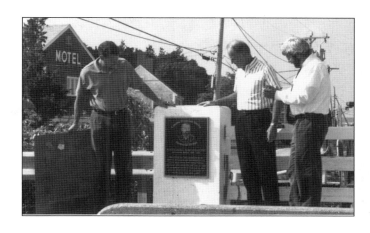

Clark (right) joined the Scituate Historical Society and the United States Life-Saving Service Heritage Association in dedicating the new plaque for the Keeper Frederick Stanley Bridge, the main access point to the Humarock peninsula.

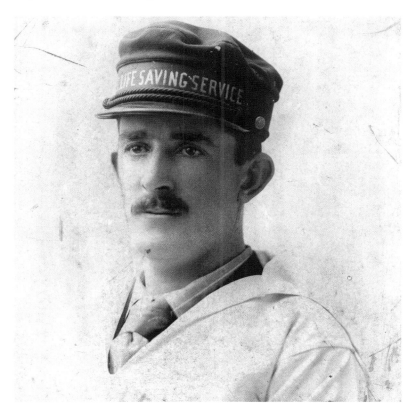

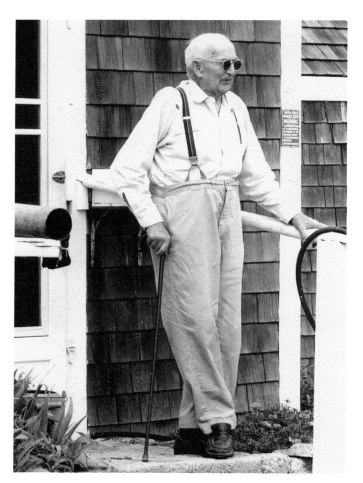

Turner recognized its historic value to the town. After reading that the government was prepared to auction the lighthouse away, Turner, then a selectman, sent his wife to Boston to purchase the structure for the town, after collecting a check for $1,000 from the town treasurer for that purpose. Their quick actions saved the lighthouse for the town, now one of Scituate's best-known attractions. On the lawn just outside the keeper's house's fence is a stone commemorating the life of the most recent town-recognized keeper, George Downton, a jack-of-all-trades handyman and devoted volunteer.

The federal government recognized nine men as keepers of Scituate Lighthouse: Simeon Bates (1811–1834), Zeba Cushing (1834–1840), Ebenezer Osborne (1840–1849), James Bates (1849–1851), Anthony Waterman (1851–1853), Alonzo Jones (1853–1856), Thomas Richardson (1856–1860), John Prouty (1891–1904), and John Frank Cushman (1904–1924). The town of Scituate, however, officially recognizes two other men as keepers of Scituate Light. Jamie Turner can be said to be one of the earliest proponents of historic preservation in Scituate. In 1916, although the lighthouse had by then been deactivated for more than half a century (Prouty and Cushman maintained a breakwater beacon) and was in bad repair,

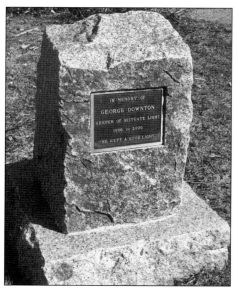

John Frank Cushman served Scituate Light during its dark years. Deactivated in 1860, the tower did not even have a lantern room atop it again until 1930, when the town rebuilt it under the rationale that a community is always judged by the beauty of its parks. Yet even with a rebuilt lantern room, no light shined from the tower again until 1968, when a harbor-facing lamp was installed. Only in 1994 did the light again become an active aid to navigation. Instead, Cushman and his predecessor John Prouty maintained a red beacon at the end of the 630-foot-long breakwater that stretches to the southeast from the base of the old tower, constructed by the Light House Board in 1891. To supplement his income, Cushman sold ice cream from the

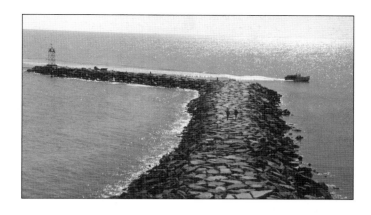

west wing of the keeper's house. Today, thousands of visitors every year walk the same well-trodden path to the end of the breakwater that John Cushman walked for 20 years.

Scituate Light, while a stopping point for Flying Santa and indelibly tied to the story of the *Etrusco,* is better known for its two young heroines, Rebecca and Abigail Bates. Local legend states that the two girls hid from view and played

"Yankee Doodle" on fife and drum as British longboats entered the harbor sometime during the War of 1812. As the boats drew closer to shore and the music sounded louder, the British feared they were sliding into an ambush at the hands of an American army ashore. Turning their boats back to sea, they left and never returned. Although no contemporary documentation exists to verify the tale, the Bates girls told their story to the press late in life, leaving open forever the question of the tale's validity but also inspiring several reenactments, children's books, and more. The girls' home still stands today on Jericho Road, possibly the oldest standing dwelling in Scituate.

John Frank Cushman and the other lighthouse keepers would have recognized this scene. Now densely populated, Cedar Point in Scituate Harbor today remains one of the most relaxing places to be in Scituate during summer. Things can get rough when winter storms hit, for sure, but the trade-off is worth it. America's first settlers never enjoyed the simple pleasures of relaxing on the porch with friends—it took the industrial revolution to bring that idea forward. Today, on Lighthouse Road, it is almost a way of life. Near the end of Lighthouse Road, on the right-hand side stands another testament to man's eternal quest for relaxation. Fisherman Tom Turner mortared a jug into his chimney, facing the northeast, hoping to catch the sounds of the cold winds that blew from that direction. The sound would carry down the chimney and across the house to his bedroom, telling him that it would be unwise to attempt to go out on the ocean that day. Thanks to the jug, Tom could stay in bed and catch up on his rest.

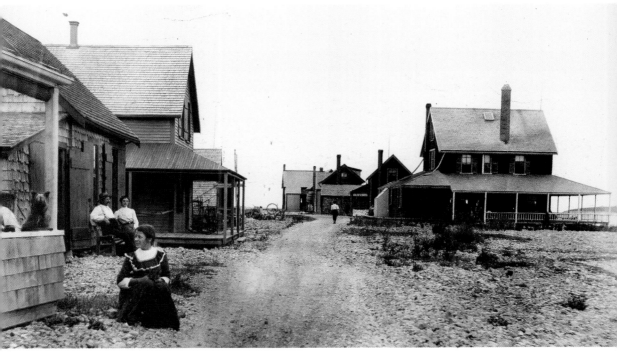

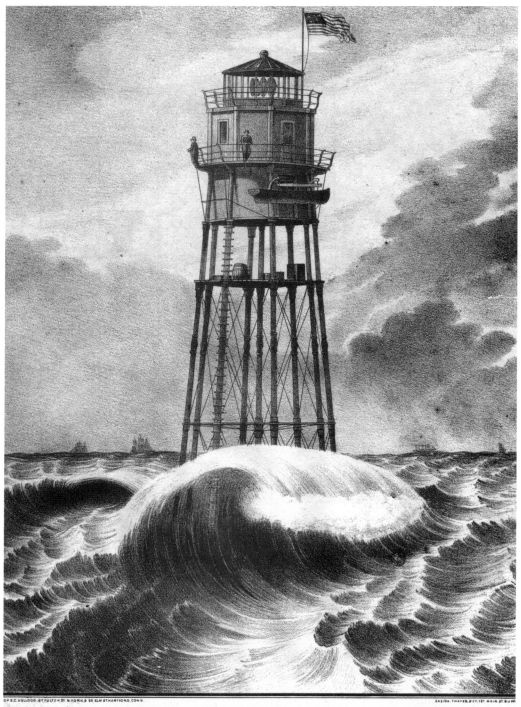

OF E.C. KELLOGG, 87 FULTON ST. N.YORK & 95 ELM ST. HARTFORD, CONN. ENSIGN, THAYER & CY. 127 MAIN ST. BUFF.

IRON LIGHT HOUSE, ON MINOT'S LEDGE.
OFF COHASSET, MASS. BAY.
First lighted Jan.ᵉ 1ˢᵗ 1850. Destroyed in the gale of April 16ᵗʰ 1851.
Height. 75 feet.-Breadth of Base. 25 feet-Diameter of Piles. 8 in. at the base and 4½ in. at top.

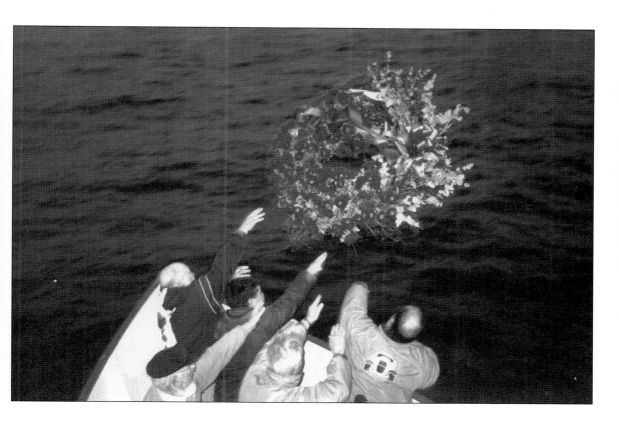

To the north lies yet another heart-gripping American lighthouse tale. When the federal government finally ascertained the usefulness of a lighthouse on Minot Ledge, they decided to build what they considered to be a cost-effective structure. The iron-pile-type Minot's Light, however, shook violently during storms, even swaying from side to side in high winds. Deaf to the worries of its keepers, the federal government learned in horror that the structure vanished into the sea on April 16, 1851, less than a year and a half after its lighting ceremony, dragging keepers Joseph Wilson and Joseph Antoine to their deaths. On April 16, 2001, on the sesquicentennial anniversary of their loss, the Scituate Historical Society brought 200 well-wishers out to the current lighthouse to witness five descendants of Antoine toss a wreath into the water in honor of their lost ancestor.

The question is often asked regarding who the first person ever was to look at a lobster and decide to eat it. In Colonial days, the bottom-feeding creatures from the deep were fed to servants and seen as unfit for society's elite classes. Today, of course, lobster is a coastal delicacy. The men of North Scituate did not care who was the first to eat a lobster. All they knew was that people paid enough money for them that a living could be made trapping them. Instead of building a better mousetrap, Scituate men worked on building a better lobster trap. With a harbor that opened up in the early 17th century (before that time, the harbor was a pond, indicated by an 1850s survey of the mouth that located cedar stumps between Cedar Point and First Cliff), Scituate has been home to shipbuilders, fishermen, lobstermen, Irish mossers, and more. The town pier today bustles with activity as boats of all sizes come and go, keeping alive nearly four centuries of seagoing tradition.

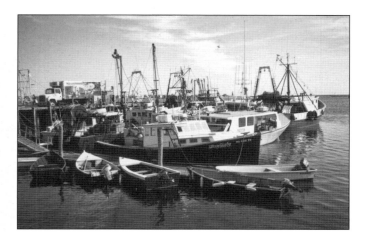

Beaches have been swept away. Lighthouses have toppled into the sea. Our ancestors would not immediately recognize the coastline as the one they settled in the 1620s. One thing that never changes, however, is the rocky outline of the Minot section of coastline, specifically the Glades. Nicknames for certain rocks have passed down through generations, such as Pulpit Rock at the Glades, Well Rock at Minot, the Pebble off Cedar Point, and Nubian Head Rock between Second and Third Cliffs. Other inland rocks, such as Hatchet Rock, have even inspired poetry. One thing is for certain— long after we have gone, these geological landmarks will remain as firm as ever.

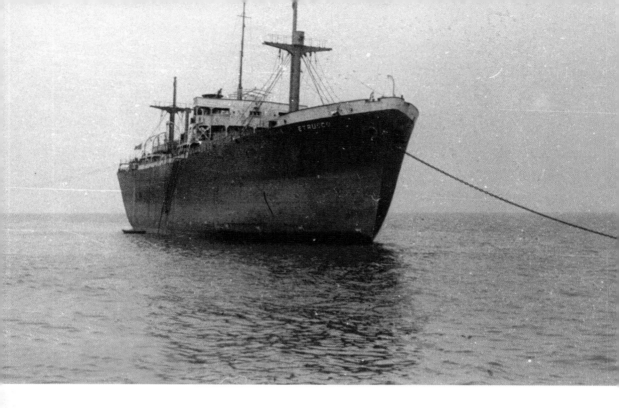

The people of Scituate have learned many valuable lessons from the sea, including lessons about themselves. When the *Etrusco* came ashore on that cold March morning in 1956, it brought with it more than 30 cold, frightened Italian sailors who needed to be fed, comforted, and steered back home. Showing the true strength of their character, the locals pulled together as a community to take care of their unfortunate and unexpected visitors, finally sending them on their way just a short time after the wreck. However, the people of Scituate soon recognized the power and value of their charitable acts and decided to carry the positive momentum gained during the *Etrusco* experience forward with a new venture. The result of that desire to help remains today in the story of the Etrusco Associates, keepers of a medical lending library, supported by donations from the local citizenry—another example of how Scituate, with its miles of coastline, will forever be touched by the sea.

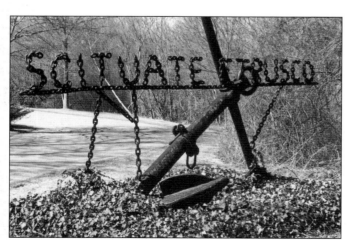

By 1900, this house had seen better days. Built *c.* 1745 by Benjamin Clapp, the house was recognized locally as a typical if not fine example of early American architecture, with its gambrel-style roof and large central chimney. Located in the Greenbush section of town, it did not share landmark status with the likes of the Old Oaken Bucket house or the Judge Thomas Clapp mansion. Few townspeople knew or much less cared that Benjamin Clapp had built the house while in his second of three marriages. By 1758, Clapp was living under the roof with three children and his last bride, Deborah Nash. He was 48, she was 22. Eighteen years later, at the age of 66, Clapp would leave his home briefly to enlist in Capt. Amos Turner's company of Col. John Cushing's regiment in an ill-fated attempt to chase the British army out of Rhode Island. In 1795, Clapp's granddaughter Lucy married

Chapter 3
HISTORIC HOMES
AND BYWAYS

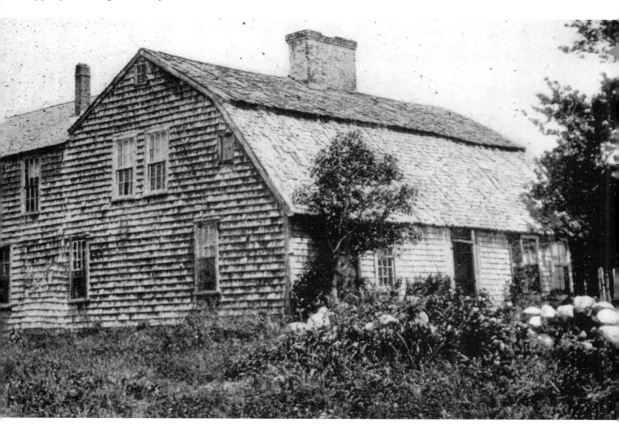

Benjamin Stetson. It was through Lucy that the house and land passed to the Stetson family *c.* 1800. By the last quarter of the 19th century, several generations of Stetson kindred had passed through the house. No one in the family seemed interested in staying on and maintaining the property. Sons grew up and pursued jobs out of town or opted to build or purchase newer homes that offered modern conveniences. Daughters simply married and moved on. To pass by the house in 1900, one would see faded paint, missing shingles, fallen sashes, and a crumbling chimney. Surrounding planting fields sprouted goldenrod and briar. Pastures enclosed scrub-oak and maple. Yet, someone still lived in the house.

Lucy Stetson was considered by family and neighbors alike to be a true eccentric. Forty years old and unmarried, she had lived her entire life in the old house. She shunned people, aside from her parents, preferring the company of the woods and meadows she wandered regardless of the season. When her parents passed away, she continued to live in the house despite having no means and perhaps no inclination to maintain the property. Finally, in 1900, family members concerned about the condition of the house and Stetson's well-being decided to sell the property. In a matter of weeks, the land was sold.

In the spring of 1901, workmen arrived on the property with the purpose of demolishing the old house, the new owner having no desire to make the necessary repairs to the ancient structure. Each man entered the house with a sledgehammer and pry bar. Outside, wagons were secured to haul away anything of value. Beams, floor planks, mantels, doors, and moldings could be reused. Everything else was tossed in a heap to be burned later.

Two weeks into the job, the workmen made an interesting discovery. Upon removing plaster and lath, it was discovered that the walls were constructed entirely of handmade brick. Soon word spread through town of this curious find, and in short time folks arrived to view what proved to be an ancient building technique as solid as the day it was constructed. It was also noted that the windows in the house had originally been smaller and more narrow. Speculation between workmen and visitors alike suggested that the house may have served as a blockhouse or garrison during the days when Scituate was under the threat of Indian attack. Local folks who were familiar with the history of the town recalled how Greenbush actually experienced such an attack at the height of King Philip's War in 1676. Many believed that the former Clapp house, situated on a hill, may have played a role in the defense of the town in those long-ago days.

As the job continued, the workmen noticed a solitary figure far off in the back pasture who would disappear as suddenly as she appeared. On certain days, the figure would venture closer and, upon being noticed, would saunter away. One morning, while a workman was in the process of pulling up a floorboard in what had been a small keeping room, he turned suddenly to find a woman standing behind him. Before he could voice his surprise, the woman spoke: "I was born in this room." It was Lucy Stetson.

Scituate's villages in the first quarter of the 20th century were often characterized by the distinctive dwellings of the two preceding centuries. Whether it was a stroll along the harbor or a Sunday afternoon drive through Greenbush or the West End, folks would stop as they still do today and admire the quaint and rustic homes that are as much part of the landscape as the stonewalls that once delineated pastures and boundaries.

The concept of historic preservation really took shape in Boston in the latter half of the 19th century with the loss of the John Hancock homestead. That city's residents, who in the past had always been content to mark significant spots with columns or stones, stood silently before the empty Hancock lot and for the first time felt that something was indeed missing from the heart of the city. What, in the name of progress, had they lost? Perhaps the first inkling of a notion toward historic preservation in Scituate took place during the dismantling of the Clapp-Stetson house at the beginning of the 20th century. The notion that something significant, and more importantly significant to Scituate and its history, had happened on this spot set minds to wondering. In less than two decades time, the people of Scituate

would come together to begin preserving their historic buildings. Today, no vestige at all remains of the old Clapp-Stetson house, which once stood at the entrance to present-day Oakhurst Lane off Country Way.

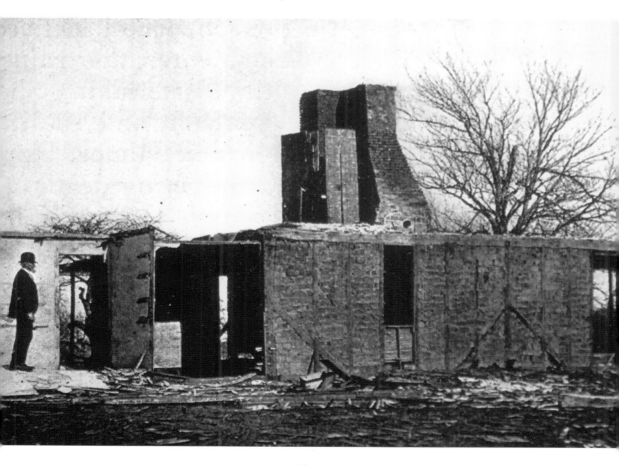

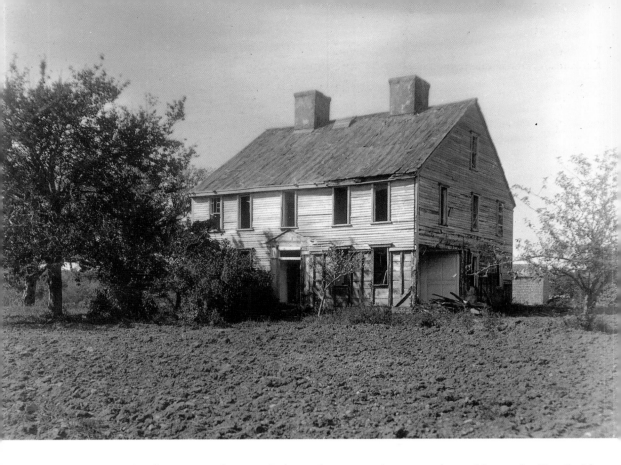

This *c.* 1890 photograph shows the 1740 Judge Thomas Clap mansion shortly before it was torn down. The farm was located in what is now the neighborhoods of Pine Oak Drive and Edgewood and Berkshire Roads in Greenbush. Born in Scituate in 1705, Clap graduated from Harvard College in 1725. Ordained to the ministry in 1729,

he accepted a position at the First Parish Church at Taunton. He later returned to Scituate in 1738 upon his appointment as chief justice of the Inferior Court of Plymouth. That same year, he purchased land in the Beechwoods that later became known as the West End. He built a Cape-style home along the highway that still survives. Two years later, he moved to the village of Greenbush, where he built a mansion that boasted two baking ovens in the common-room fireplace. While Clap's son Thomas Jr. served as an officer in the British army during the French and Indian War (1755–1763), Clap was appointed colonel of the local militia. A loyal subject of Great Britain, he was also the owner of several slaves who were liberated upon his death in 1774. The only surviving trace of the Clap estate today is the family burying ground located across from Fitts Mill.

It is hard to believe that this quiet crossroads is today one of the busiest traffic intersections in Scituate. The older photograph, taken on Thanksgiving Day 1876, shows three generations of the Clapp family at Greenbush. The house in the background was at the time of the photograph the home of Elijah Clapp. Although it was believed to have been built by a member of the Stockbridge family in the mid–1700s, several generations of Clapps lived in the house well into the 1900s. Until recently, the property was known as Alice's Greenhouse, run by Scituate native Alice Hallin.

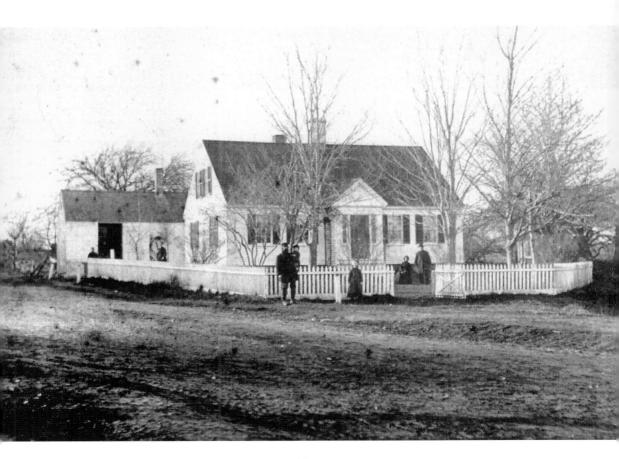

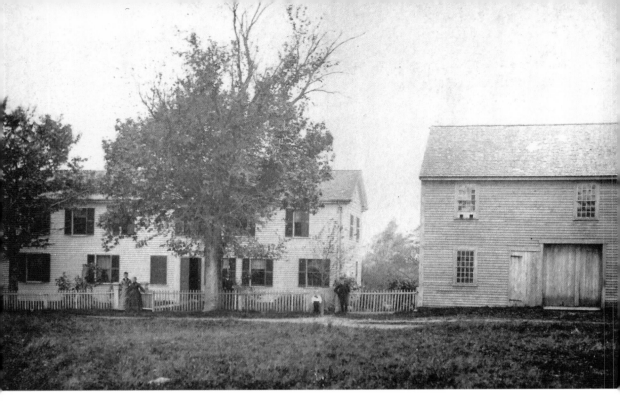

In 1782, Scituate landowner John Colman sold 17 acres of upland to William Vinal for 76 pounds. The deed is dated January 10, 1782, in the sixth year of the independence of America. A housewright by trade, William Vinal was a veteran of the Revolutionary War who upon his return in 1780 married Lucy Mann, daughter of Capt. Thomas Mann. Throughout the 19th and 20th centuries, what is now 17 Common Street underwent extensive alterations that have made it certain Vinal would not recognize his home if he were to stop in for a visit. What was once his 17 acres is now a portion of Wheeler Park. However, one parcel of land that has changed little from Vinal's time is the Old Trayning Field (pictured in the foreground of this *c.* 1880 photograph), situated between Stockbridge Road and Common Street. What is now recognized as a quaint park is where the barking commands of militia captains from King Philip's War of 1676 to the Civil War of 1861 once resounded.

When the Civil War ended in 1865, Scituate's surviving veterans returned home to what they hoped would be the life they had known four years earlier. To a fortunate few, this was possible, but four years of the hardship and horrors of war brought many men home broken in spirit as well as body. In 1875, a group of local veterans gathered on a warm spring evening at what was then Jenkins Hall on Country Way and organized the George W. Perry Post No. 31, Grand Army of the Republic, pledging undying loyalty, charity, and fraternity to each other. Scituate's Perry Post would devote the next 50 years to promoting veterans' causes and instilling in the public a sense of civic and patriotic pride. Shown here is a rare image taken on Memorial Day *c.* 1910 as the aging boys of 1861 march up Union Street, now Stockbridge Road, toward the

main gate of Union Cemetery to pay respects to their fallen comrades. Across the street from the cemetery stands the Old Trayning Field, today a beautiful park with a tree-lined walk.

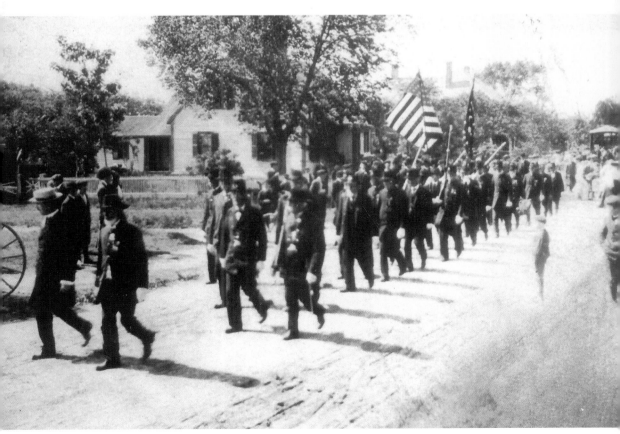

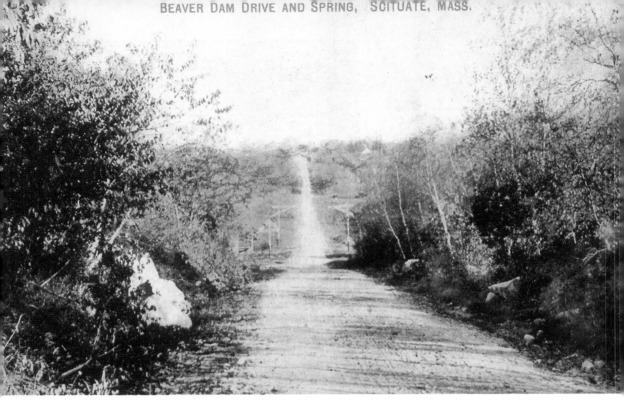

One can see from this photograph taken almost 100 years ago that the thick bramble of Beaver Dam Hill has changed very little. Formerly known as Willow Street, a natural spring in the area presented a business opportunity that became the Beaver Dam Springs Company, purveyors of bottled water in the early 1900s. Years after the business closed, residents continued to show up in station wagons armed with plastic jugs until the pipe was capped by the town, due to purity concerns in the 1980s. Glass bottles from the Beaver Dam Springs Company occasionally show up at local flea markets and antique shops. Note in this photograph the railroad crossing at the bottom of the hill.

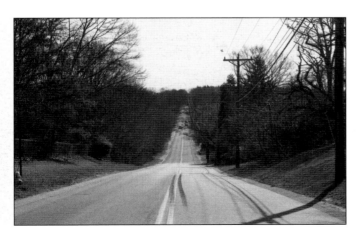

Although Scituate has lost many a grand old home to fire, neglect, and the wrecking ball, many homes were preserved by being moved to other locations. Building movers enjoyed a brisk business in the late 19th and early 20th centuries. In addition to homes, barns and other outbuildings were often moved by oxen to new locales. This home, built by Revolutionary War veteran Anthony Waterman in 1789 and now located at 26 First Parish Road, was moved from its original location at the corner of First Parish and Stockbridge Roads, the former location of the Allen Public Library. Waterman was a successful shipwright who owned a wharf and provision store at the harbor. It was at the harbor's Kent Shipyard in 1813 that he built two schooners, the *Jolly Tar* and the *Old Carpenter*. Recent research has suggested that both vessels were burned when the British navy paid a visit to the Scituate coast during the summer of 1814. In 1824, the property was purchased by Capt. Nehemiah Manson, whose sons

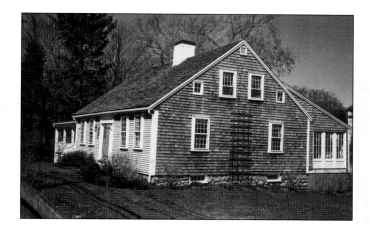

Thomas and John would follow in their father's footsteps as master mariners. The house remained in the Manson family until 1893, when Nehemiah's heirs sold the property to the Satuit Library Association for use as a library until 1910. When it was decided to erect a new library on the site, the house was moved to its present location.

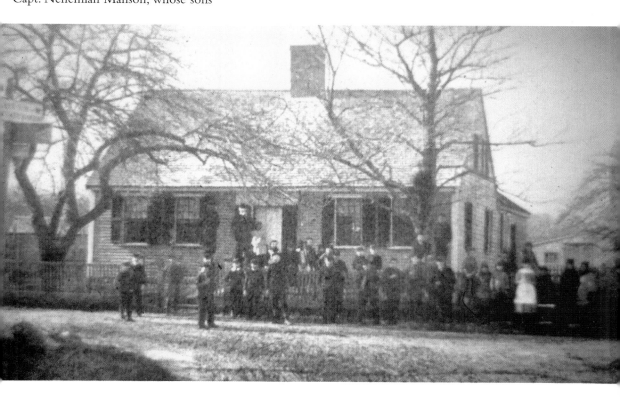

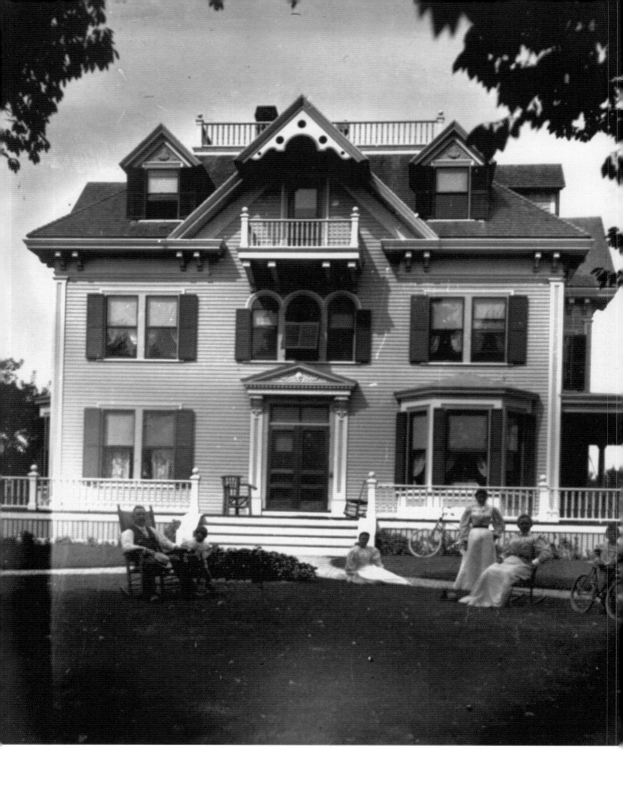

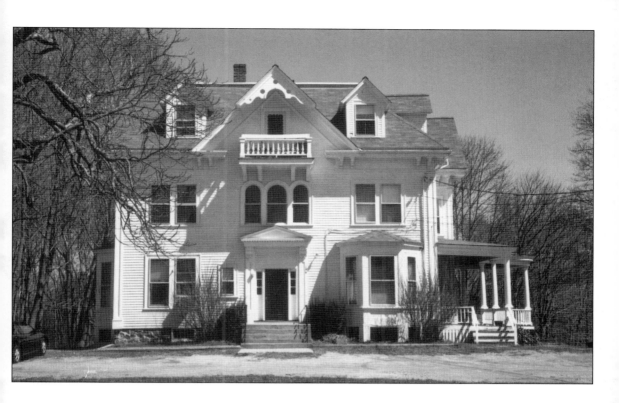

With the discovery of Scituate as a summer retreat in the late 19th century, many well-to-do Boston merchants escaped the grind and heat of the city for the peace and quiet of the South Shore. Although many built cottages just beyond the reach of the tides at Minot, Mann Hill, Shore Acres, Sand Hills, the Cliffs, and Humarock, some chose to reside along quiet country village roads in homes such as this comfortable Queen Ann–style home built by businessman George Yenetchi, seated in the foreground of this Frederick Damon photograph (opposite page). Yenetchi was a successful liquor distributor who may have chosen this site on present-day First Parish Road because of its proximity to the harbor and the railroad station, then located across the street where the fire station now stands. As can be seen in the present-day photograph, the grand porch where many a lazy summer day was passed is long gone. The house has been divided into apartments.

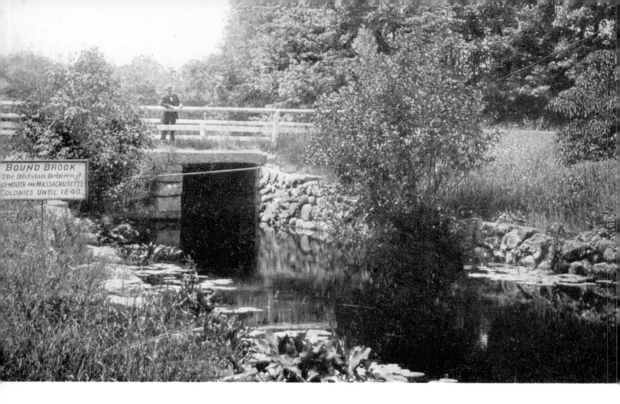

The town's earliest settlers used waterways as efficiently as they used roadways. The North River, apart from being an early American shipbuilding mecca, also served as transportation to inland towns, power for water-driven mills, and more. Rivers and streams also served as convenient boundary lines on early Colonial maps. Bound Brook, shown here, once served as the division line between the Plymouth and Massachusetts Bay colonies. Satuit Brook, shown in the modern photograph, still runs mostly unnoticed under Front Street today. Its true importance to the town comes from that fact that it has given its aboriginal name to the community. Satuit, or cold brook, has been Anglicized to Scituate.

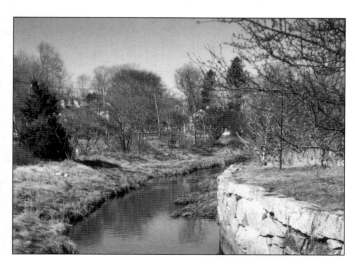

The responsibility of guarding and maintaining those borders has always fallen to the local selectmen and selectwomen. Under state law, the selectmen are required to perambulate the bounds of the town in coordination with the selectmen of bordering towns. The selectmen of Scituate, which borders Cohasset, Hingham, Norwell, and Marshfield, most recently accomplished this duty in February 2002. Here, from left to right, selectmen Jim Pollard, Susan Phippen, and Shawn Harris meet in a marsh off Border Street with Cohasset selectman Fred Koed, posing for a photograph by Scituate town engineer Paul Scott. To make the event even more memorable, the Scituate Historical Society arranged to meet representatives of the historical societies from the bordering communities at each marker and to exchange gifts.

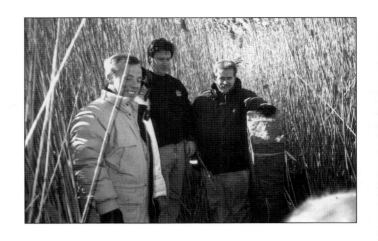

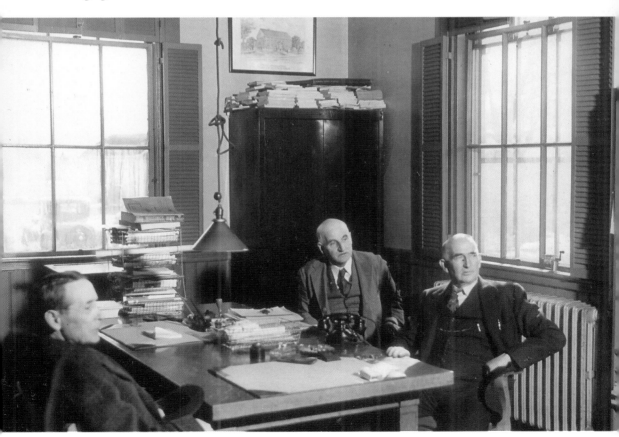

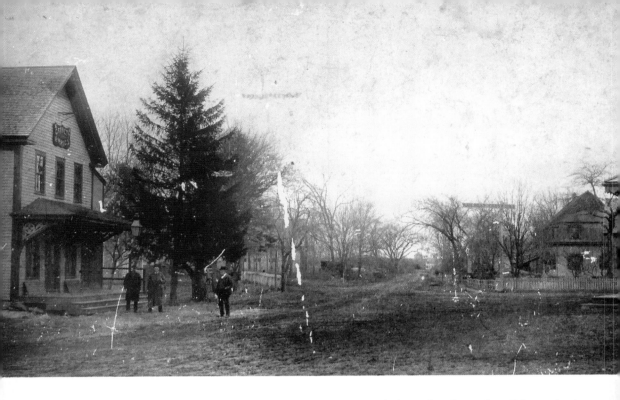

When sorting through a collection of old photographs, whether the subject is an ancestor or a landscape, we are often surprised when we find out who or what the subject is. In many instances, there is no scribbled message on the back to tell of whom, where, or when the photograph was shot. In this case it is hard to believe that the photographer stood in the middle of another of what is now one of Scituate's busiest street intersections (and it is even harder to believe that the author did exactly that today). Looking east, we see that what is now asphalt was in the late 19th century standing wood lots. On the left we can see what was then Gannett Hall. In time, a storefront was added, but the building can still be recognized today.

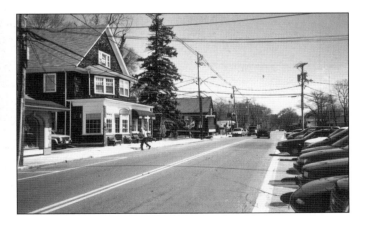

In the 19th century, horse troughs were a regular sight along roadways and in village squares. In the early 1900s, town officials working with our local Grand Army post introduced beautiful cast-iron fountain-like troughs that were placed at the harbor, in Greenbush, and in North Scituate. Two troughs survive today. As the automobile replaced the horse, gas stations sprang up along roadways, such as Merritt's, located on Gannett Road on the way to North Scituate Beach. Although the pumps are long gone, the house remains. Note the two granite gateposts in the road.

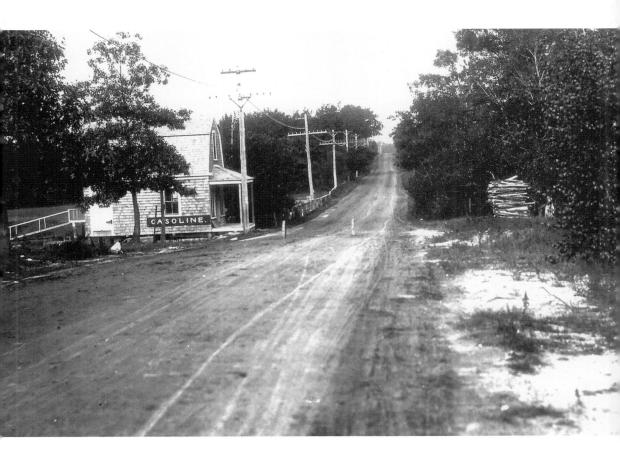

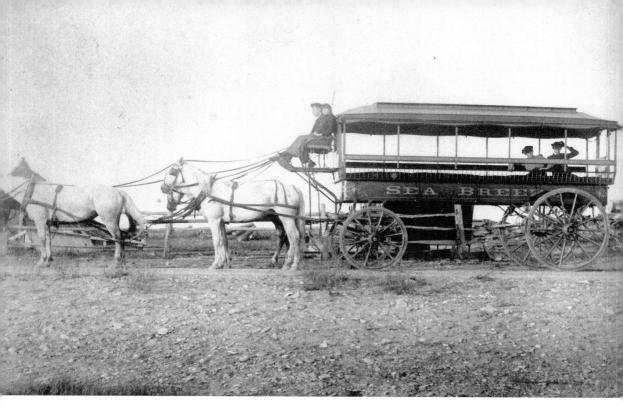

When visitors stepped off the train at North Scituate, Egypt, or Greenbush, the first thing they often noticed was the horse-drawn barge waiting to take them to perhaps the Stanley House at the harbor or to the Minot Hotel and Mitchell House at North Scituate Beach. In addition to moving tourists, the barge was also used for town parades and serviced Scituate's many public schools. Many former pupils recalled the dusty roads of springtime and the icy chill of winter. Remnants of those days remain, such as the shelter at the North Scituate train station. With so many of Scituate's homes, highways, and byways still the same as in years past, a turn-of-the-century conductor could very well still find his way along the old route.

By the mid-1800s, two of Scituate's major industries, the mackerel fishery and shipbuilding, had slowed to mere trickles. By 1867, only 17 percent of the heads of Scituate households were engaged in agriculture. Two cottage industries, shoemaking and mossing, never became major industries, with many local shoe cutters working in neighboring communities such as Hanover, Abington, Bridgewater, and later Rockland and Brockton. Although the harvesting of Irish moss was a growing industry, it was always a seasonal occupation.

As we have already seen, the discovery of Scituate as a summer playground in the late 19th century created new markets and stimulated old ones. Aside from the lumber and supply businesses, many family farms revived to meet the demands for fresh poultry and garden produce. Although many of the more affluent summer residents brought their help with them from Boston for the season, many hired locals to care for their cottages and maintain their property. When Thomas W. Lawson and his Dreamwold estate arrived in 1900, he employed hundreds of Scituate residents to maintain his vast

THE BUSINESS OF A SMALL TOWN

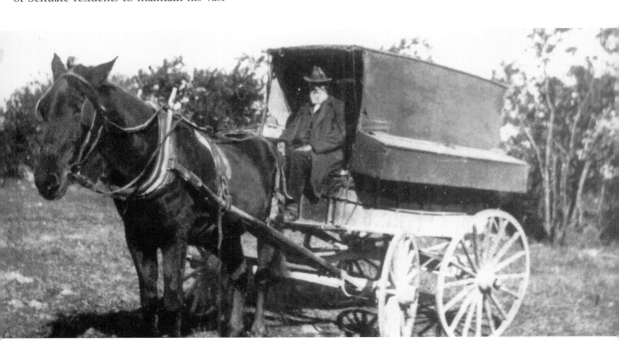

property. In addition, public works projects such as water, sewerage, and road improvements all required a steady labor force, demands that are still with us today.

Born in Scituate in 1820, Roland Turner was perhaps one of Scituate's busiest citizens. When he was not operating his store-on-wheels, from which a lady could purchase a pair of high-button shoes or a bottle of cod-liver oil, he was serving the town of Scituate as a member of the board of selectmen or as tax collector. On many an occasion, when he pulled up to a resident's home in his wagon, folks did not know if they needed something for the home or if they were behind on their property taxes. To add to his civic duties, Turner also acted as the town's recruiting agent for the Commonwealth during the Civil War.

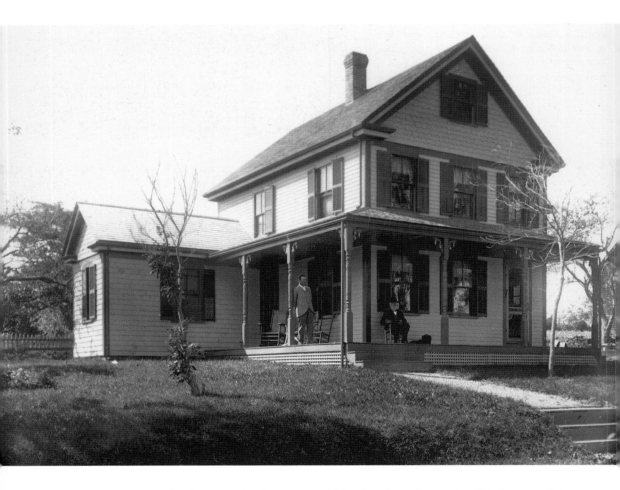

When not out earning his living, Roland Turner could be found on the porch of his home at Scituate Harbor. His house remains today, next to St. Mary's Church. Frederick Damon, the photographer, must have been in the right place at the right time. It would not have been easy to catch Roland Turner in a relaxed pose.

Years after the introduction of the automobile, horse-drawn wagons continued to serve local tradesmen. During the Great Depression and World War II, horse carts and wagons experienced a revival of sorts when rubber and petroleum were rationed and the automotive industry changed over to wartime production. There are still many folks around today who remember the arrival of the iceman or the shrill cries of the ragman. Scituate's Prescott Damon (1898–1956) ran a successful hauling business using both auto and horse power. He also owned and operated a school bus, hauling generations of pupils across town. Damon served as a Marine Corps veteran of World War I, and former passengers from his school bus can still recall his no-nonsense approach to those who rode his route.

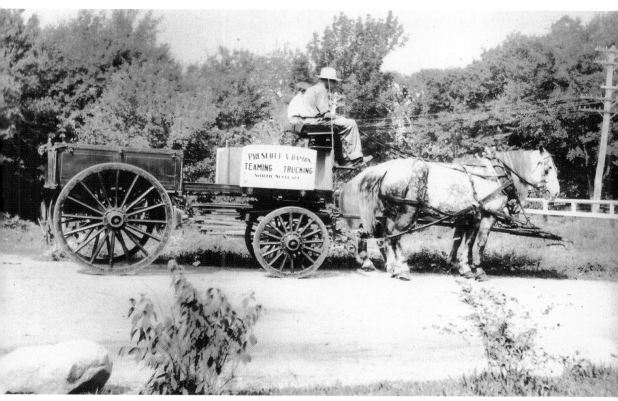

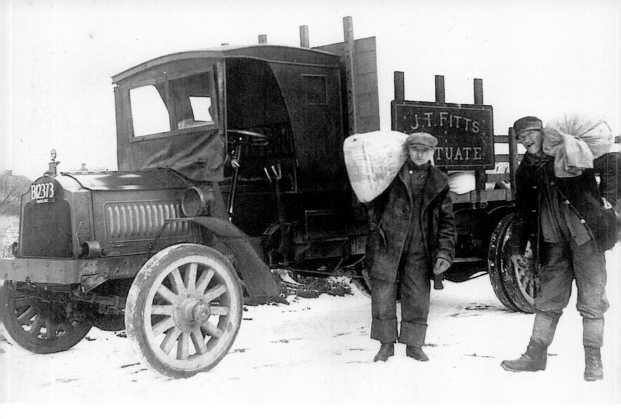

Pictured here are two "reliables" making a delivery from Fitts Mill in Greenbush. Throughout the last century, the Fitts family provided hay and grain to the local farms and stables. In later years, their stock expanded to include varieties of birdseed and bird feeders, pet food, and lawn seed. Although the store has changed ownership, the name and landmark grain barn remains.

For the many buildings in Scituate that have disappeared over time, it is interesting to see that many survive, although greatly altered. Many buildings have been moved from their original locations to be reincarnated as dwellings or other modes. Many of Scituate's former schoolhouses of the 19th century survive today as private residences. In one case, a former schoolhouse in Greenbush is now a hay barn. In this photograph, what was once a traditional New England farmhouse is now the main office for the Anderson Fuel Company on Gannett Road in North Scituate.

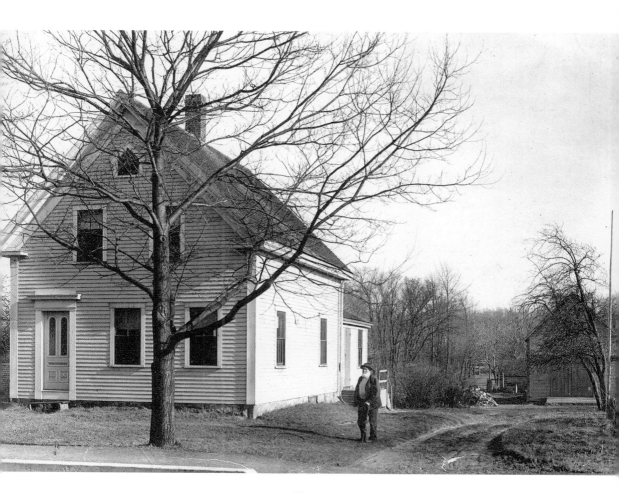

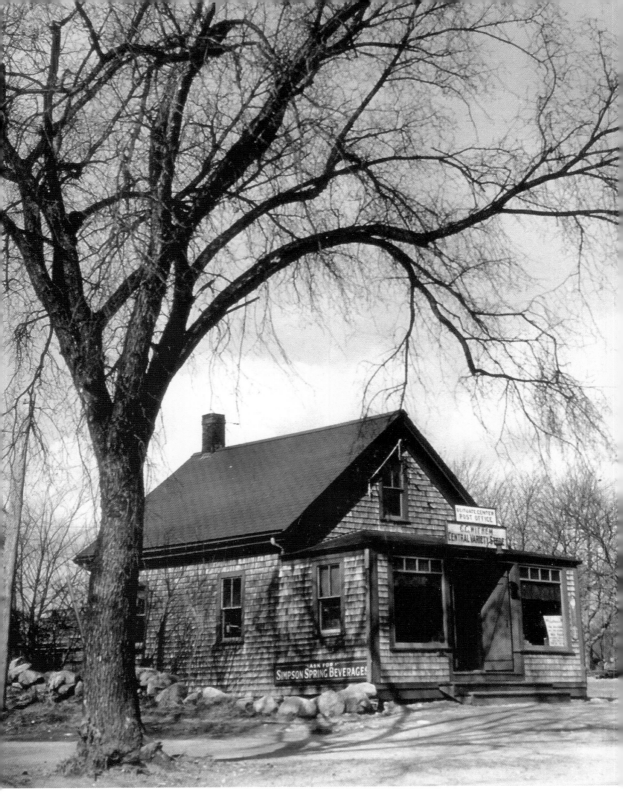

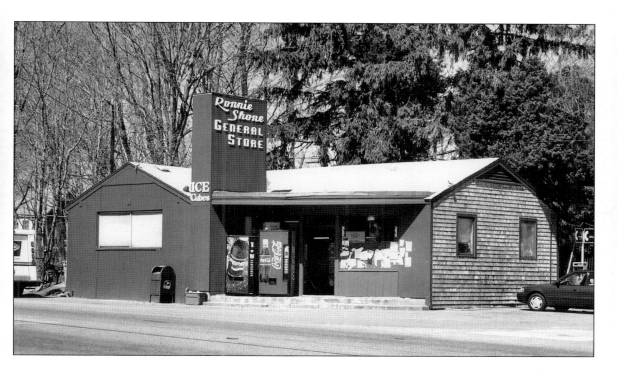

Before the development of supermarkets and reliable personal transportation systems, it was common for each village within a town like Scituate to have its own general store. These stores often served as anchors for the neighborhoods they served. They often performed dual roles as both general stores and post offices, and additionally as a source for outside news before the advents of radio and television. Pictured on the opposite page is the establishment of Mr. and Mrs. Withem, who ran their store and post office where today another landmark stands, the Ronnie Shone General Store. One can see in the photograph evidence of a more relaxed pace of life. Where now we have a very busy traffic light was once a native elm.

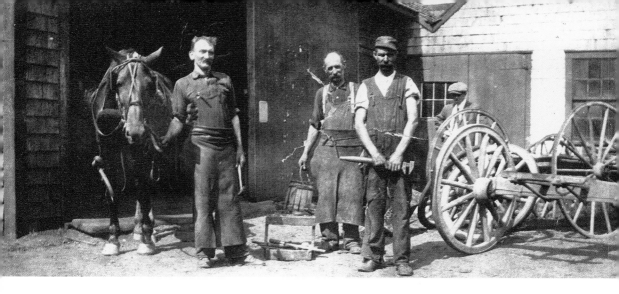

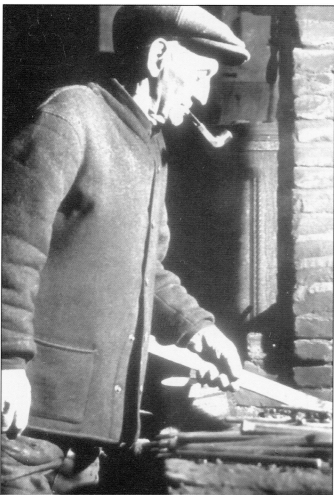

Sometime in the late 1880s, Liba Litchfield and his brother joined their father Otis in the family blacksmith shop. When their father died, the brothers continued to run the shop in North Scituate. It is now occupied by the Wilder Brothers Garage parking lot. When the newer photograph was taken, Liby, as he was known to family and friends, was 72 years old and still arriving every morning to stoke up the forge in preparation of a day's work. A hard worker his entire life, Litchfield often fell asleep in his wagon on the way home. His horse, however, had traveled the roads so many times that it would inevitably bring him back to his barn safe and sound. His wife, never worrying, would come out to the barn to find him snoozing upright, reins in hand.

Before the arrival of the big supermarkets and with the increased demand from a growing seasonal population, family farms revived in Scituate and neighboring towns. Customers seeking fresh produce within their own neighborhoods were seldom disappointed when they came upon road signs announcing that cucumbers, squash, peppers, beans, corn, and, of course, pumpkins for Halloween could all be purchased on the spot. Farm stands recalled around town were Ellery Hyland's on Cedar Street and later Arthur Rodriques's on Summer Street in the West End. Set back from the intersection of Grove Street and First Parish Road was Ford's Cider Mill, which experienced a boom in business during Prohibition. Until recently, Prouty's operated at the Centre. On the Driftway, Pitcock Farm owned by the Gomes family operated into the early 1980s. Depicted here is an advertisement for the Litchfield farm stand that operated on Country Way. Today, only two farm stands survive, Bill Steverman's

on Country Way and the 3A Farm on the Chief Justice Cushing Highway.

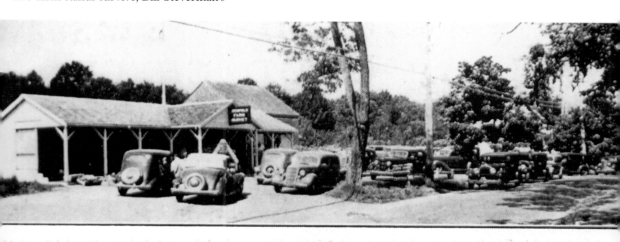

Litchfield Farm Market
— COUNTRY WAY —
NORTH SCITUATE, MASSACHUSETTS

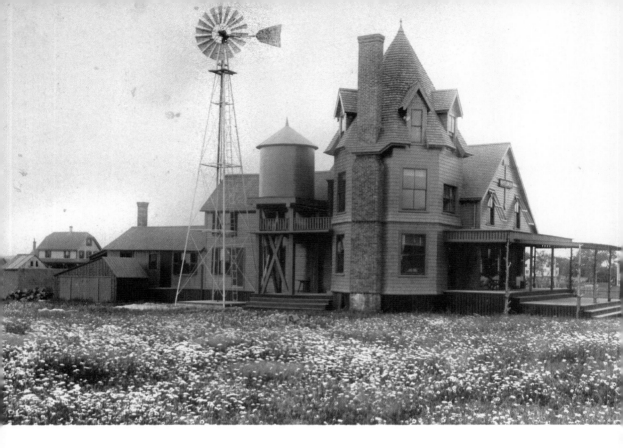

The boom in boardinghouses at the end of the 19th century, such as the Mayflower on Collier Avenue in Minot, led to a concurrent rise in curio and trinket shops. Everybody who came to Scituate wanted a souvenir, and the local businessmen were more than happy to oblige. Today, summering in Scituate still provides the visitor with ample opportunity to find that one thing that will forever remind him or her of sunny days by the seashore through the many gift and antique shops that line Front Street at the water's edge.

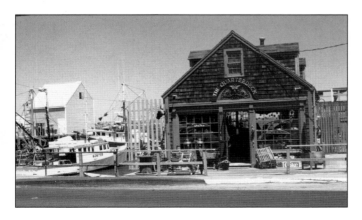

Those same visitors, of course, needed food for themselves and for whomever they planned on entertaining. Again, local entrepreneurs were ready to take care of the demand by supplying summer guests—as well as year-round residents—with food, delivered straight to the front door. Bearce's Moderne Market on Front Street, among others, led the way.

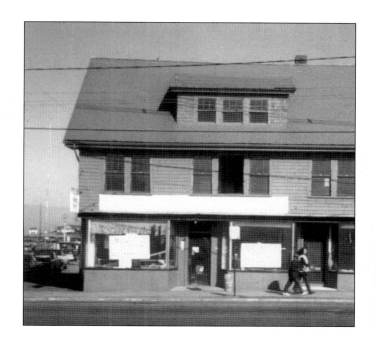

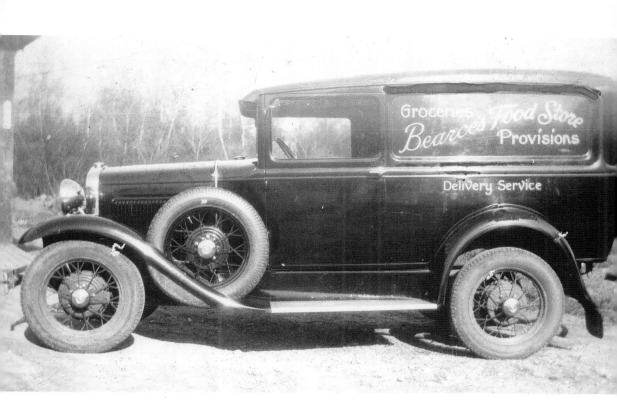

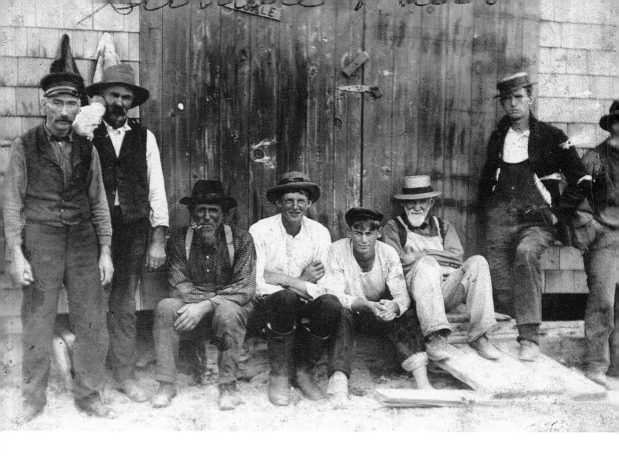

With no inscription on the back of this photograph, it is hard to tell what job exactly these men performed. There is no doubt, however, that they worked on the sea, either as mossers, fishermen, lobstermen, or in similar capacities. It can safely be assumed, however, that they also served as volunteer lifesavers with the Massachusetts Humane Society. The society looked to local boatmen to handle its rescue craft, offering rewards for doing so that could either consist of cash or medals. That organization's physical history has nearly disappeared, as only a precious few of its buildings still stand, such as this old boathouse at a boatyard on the isthmus between First and Second Cliffs.

With so much of the town's business being carried on by the sea, the town pier has always been a very active spot. In years past, it welcomed visitors to local hotels with food and transportation. Today, its clientele consists of the lobstermen and fishermen who bring their daily catch to local restaurants.

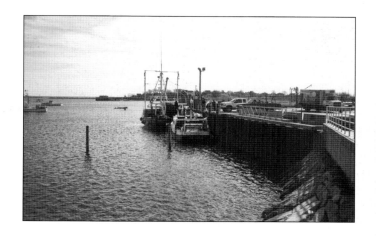

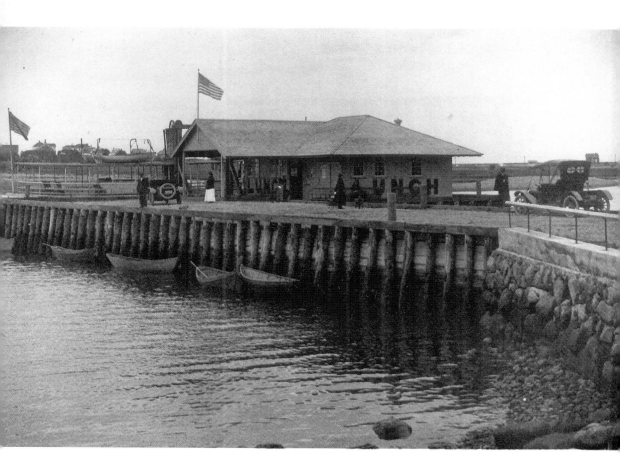

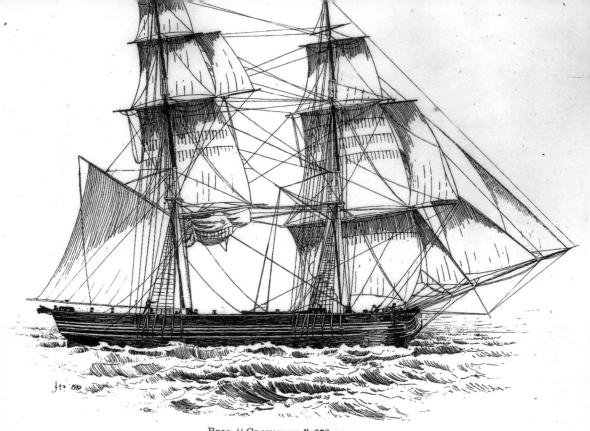

BRIG "CRONSTADT," 273 TONS
Built at Briggs' Yard, Hobert's Landing, in 1829, by C. O. & H. Briggs.

Between 1690 and 1870, North River shipbuilders constructed and launched at least 1,025 vessels of significant tonnage. With miles of virgin timber, access to the sea, and bog iron ore for forging chains and anchors upriver in Pembroke, the North River had everything a shipbuilder could need.

Toward the middle of the 19th century, however, the woodlands had begun to disappear, and the river pilots had tired of guiding their vessels from end to end, especially frustrated by the final two-mile leg to the sea. In 1854, the local mariners petitioned the federal government to cut a canal between Third and Fourth Cliffs, easing access to the sea. The government balked at the idea, suggesting instead a canal from the river to Scituate Harbor. Neither suggestion was instituted, and the shipbuilders moved off the river altogether, launching the *Helen M. Foster* in 1870 as the last of the great North River vessels. Twenty-eight years later, the Portland Gale disintegrated the very beach the mariners had hoped to have removed. Today, metal signs dot the river's edge, standing as silent testimony to the industrious nature of Scituate's early settlers.

In less than a year's time, Tom Lawson turned the town of Scituate upside-down, unearthing and shaking the roots of the nearly 300-year-old community. The year 2002 marks the centennial of both the launch of the *Thomas W. Lawson,* the world's only seven-masted schooner, and the completion of Lawson Tower, the most photographed water tower in the world. His Dreamwold farm immediately came to be known as one of the finest and best-stocked farms in the United States, with champion dogs, cattle, and horses all gathered within several miles of Kentucky-style fencing that surrounded the estate. Today, most of the Lawson-built structures remain as silent reminders of a man who was easily the most controversial figure in the town's history.

Chapter 5

THE
MAGNIFICENCE OF
TOM LAWSON

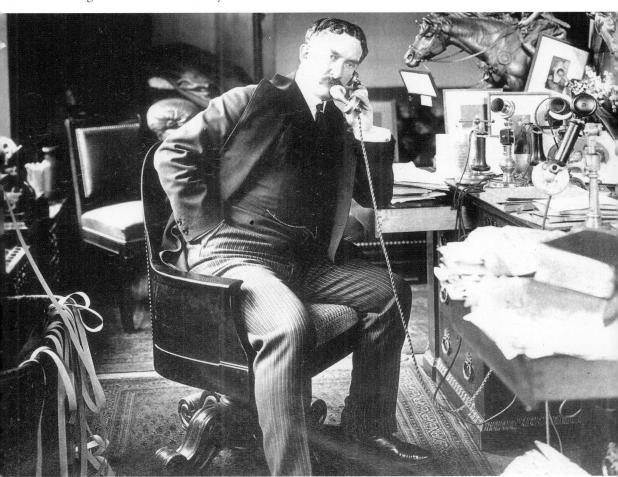

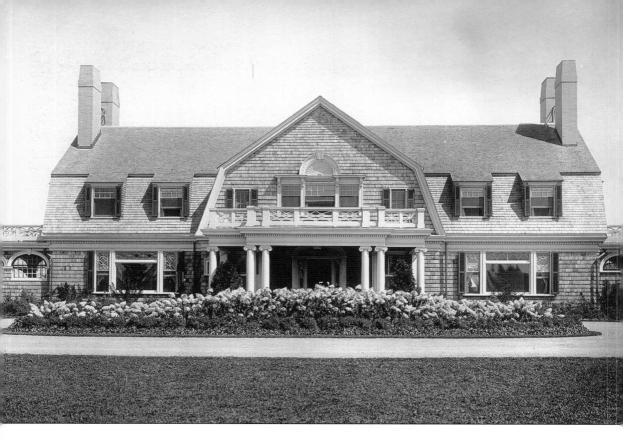

A seasonal county seat such as Dreamwold required a comfortable manor house for the estate's primary occupants, Tom and Jeannie Lawson and their six children. When reflecting upon the outlandish adventures in ostentatious architecture that defined the Victorian era in America, one can truly appreciate the simplicity of Lawson's controlled, Dutch Colonial theme. With as much money as Lawson had at his disposal—estimated to be around $60 million—it would have been easy to go overboard and construct any manner of castle-like monstrosity that came to mind. Instead, Lawson's architectural legacy to Scituate is one of classic style and elegance. The manor house today rests as it did then on Branch Street, as one of the country's unlikeliest condominium developments.

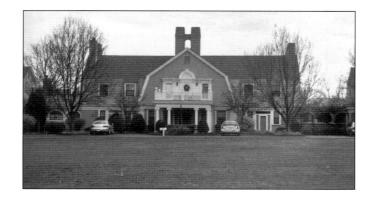

With hundreds of horses on his estate, and even more acres than horses, Lawson had room enough to construct at Dreamwold a mile-long racetrack. His stable consisted of everything from prancers and trotters to workhorses and racers. Boralma, Lawson's favorite and his "charity" horse, lost only once, and he blamed that unique occurrence on the fact that he had forgotten to bring his lucky pocket watch to the track with him that day. The winnings of every other race he donated to charity. The track came complete with a reviewing or judging stand from which he could watch each and every one of his horses train whenever he wished. In the mid-1980s, when the Dreamwold condominiums were opened, the developers replicated the reviewing stand,

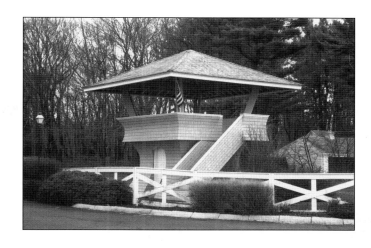

now a landmark on the lawn in front of the manor house on Branch Street.

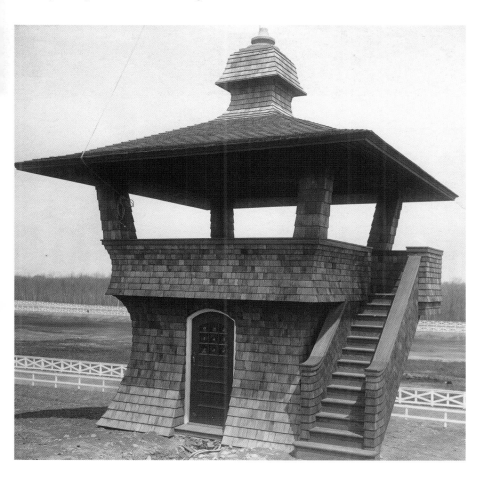

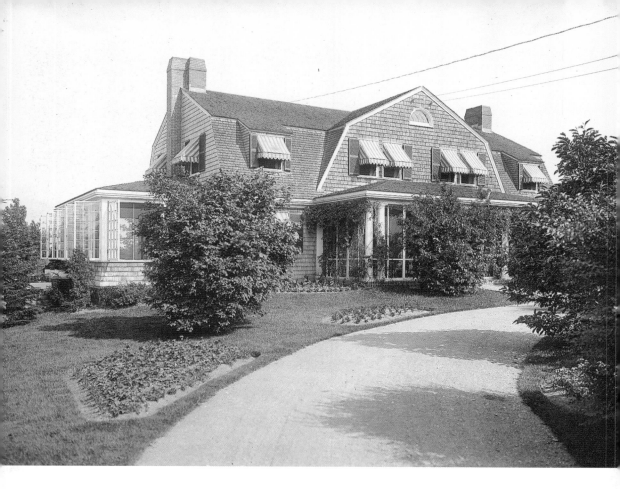

Most of the permanent workforce on the Dreamwold estate lived either in barracks-style housing, such as what is now known as the Sunlight building on Branch Street, at one point briefly a retreat home for the blind, or they lived in the buildings in which they worked. Stable hands lived on the second and third floors of those buildings with convenient, if occasionally foul-smelling, living quarters. The manor house staff lived in apartments connected to the main home. Other individuals, such as the manager of the estate, the man upon whose shoulders Lawson placed the everyday operations of the farm, lived in their own homes. Manager George Pollard lived in this home on what is now Curtis Street, which came with a beautiful and grandly built stone fireplace, still intact today.

With six children rapidly growing up, Lawson ordered homes built for them around the estate. Three of his four daughters—Marion, Gladys, and Dorothy—lived in their own houses on the corners of Branch and Curtis Streets and Country Way, structures still standing. Each is in the same Dutch Colonial architectural style used on the manor house—and, for that matter, throughout the estate—yet each has a distinctly different set of architectural detailing to distinguish one from the other. Lawson's son Arnold lived in this unique home, which still stands today on Curtis Street not far from his sisters' tiny crossroads village.

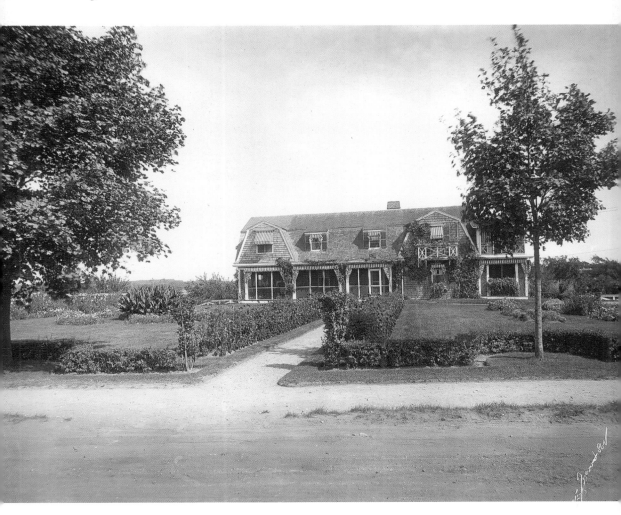

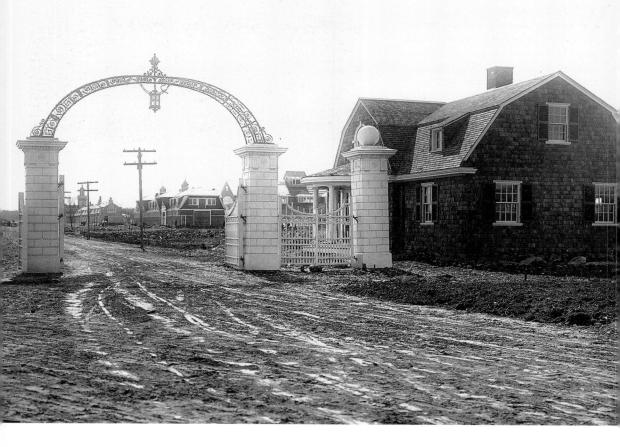

Three sets of gates marked entrances to Dreamwold. The best-known set still stands on Branch Street. Another set—the main gates, which once stood at the entrance to what is now Lawson Road at Egypt—has since disappeared. The road paralleled the track that brought Lawson into Boston every day by train. To access the estate, visitors had to obtain a pass to the grounds at the lodge, on the right of the photograph, and received instructions to stay on marked pathways. Within a year of opening his estate to the public, Lawson found that for security purposes he had to establish this pass system. The local press noted only one trespasser beyond that point. Preacher Billy Sunday figured that he had no need for such formality. Instead, he jumped the fence and knocked on Lawson's front door.

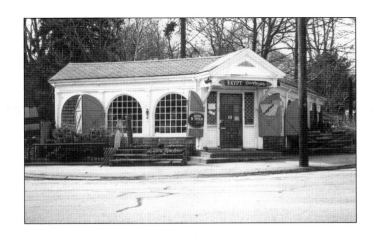

With as many projects in the air as Lawson had going at any given time, timely communication was of the essence. When he realized there was no local post office for the Egypt section of Scituate, he simply built one just outside his main gate, next door to the main office building of the estate. Long after Lawson had left Scituate, that structure burned down, eventually to be replaced by a new building. The new building was later abandoned by the postal service and left to deteriorate. Today, the building that replaced the Lawson-built post office is a local landmark and the saving grace of many a dehydrated child on a hot summer's day. Although officially known as the Egypt Country Store, most local kids know it affectionately as "the Postie."

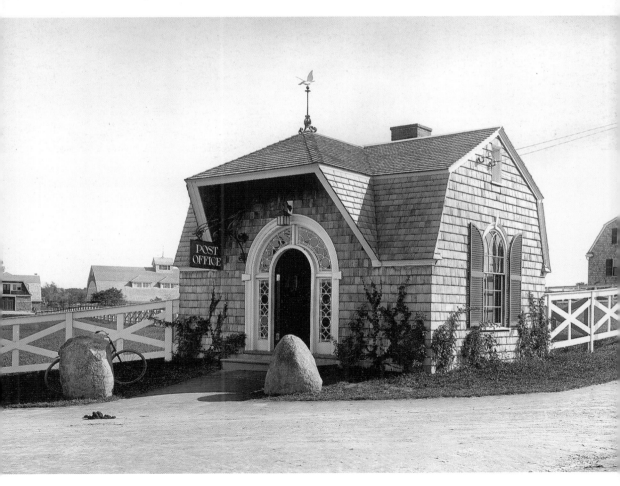

M iles of Kentucky-style fencing, apropos to one of the world's most famous stables, surrounded the Lawson estate. As far as the eye could see in any direction, thousands of roses crept and crawled along the streets, showcasing Lawson's love of all things natural. Lawson's own workmen started the tradition, for better or for worse, of taking cuttings from the roses and planting them in gardens around Scituate. Many such plants can still be seen today. Much of the Dreamwold fencing remains today as well, most notably on Branch Street.

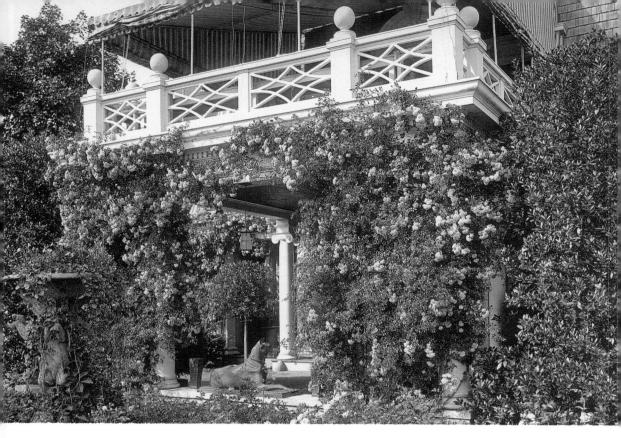

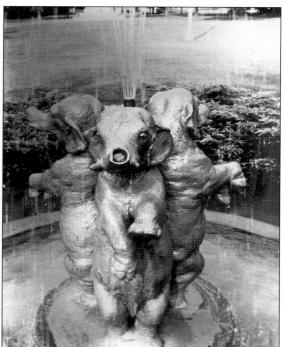

The magnificently overflowing beauty of Lawson's Dreamwold may never be recaptured in Scituate, for never again will such tracts of open land be available for development. We are left with dozens of reminders, however, of what once was. Lawson Common—whose many uses have included a church common, a drilling field for the town's militia, a buffer zone for Lawson's manor house, and the town's home to the many monuments that memorialize Scituate's fallen heroes—came to reach its current state through the power of Lawson's will. In the center of that common stand three tiny elephants with upturned snouts, who each summer day playfully toss streams of water into the air. Lawson superstitiously believed in the luck of elephants and of the number three. If you look closely on the left-hand side of this picture, you can see just how important those three little characters were to Scituate's most famous citizen.

Scituate simply has a plenitude of recorded history. With settlement as early as the 1620s, the town can reflect upon nearly four centuries of anecdotes, tragedies, and triumphs. Thus, it should come as no surprise that the Scituate Historical Society is a very active organization. Maintaining nearly a dozen historic sites, from a mill to a lighthouse to a water tower to an old school and beyond, historic Scituate has something for everyone. While flashes of inspiration toward the preservation of the town's antiquities hit various individuals from time to time before 1916, two events that year led to the solidification of the historic preservation movement in town. First, Jamie and Jessie Turner's quick thinking to save Scituate Lighthouse for the town inspired private donors to help pay for its purchase and eventual restoration. Then, a small September gathering pulled together the idea of the

Chapter 6

THE SCITUATE HISTORICAL SOCIETY

formation of the Scituate Historical Society. Starting with the Cudworth House, which stands today on the grounds in front of the Gates Intermediate School, the society was well on its way to its current status as a prolific steward of New England history.

At the corner of Greenfield Lane and Stockbridge Road stands the classic Cape Cod–style Mann House. Home to several generations of the Mann family, the farmhouse is now a showplace for all sorts of Americana, from furniture and toys to farm and sailmaking tools. The spirit of the last resident, Percy Mann, still dwells amongst the artifacts both in the house and on the grounds out back. A true eccentric, Percy shunned contact with most people, going as far as crossing streets and walking through briars to avoid conversations. When told he would need a license, registration, and license plate to drive his car, he instead drove it into his yard and parked it in protest for good, even allowing a tree to grow up through its middle. The car remains there today. The Mann House grounds today are also home to an award-winning wildflower garden, planted with mostly wild and predominantly native plants.

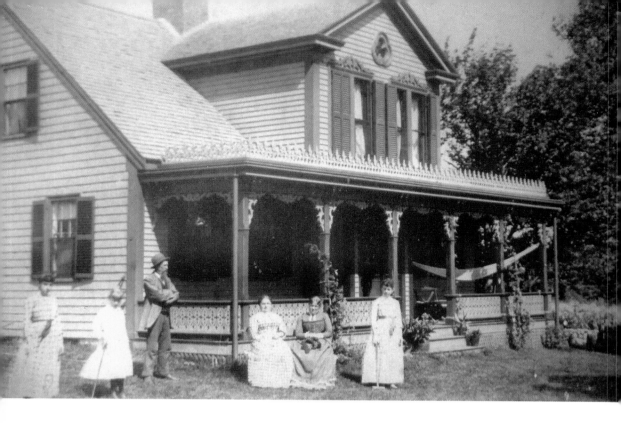

In February 2002, the Scituate Historical Society opened the doors to the newly remodeled Old Oaken Bucket Homestead, presenting for the first time a showing of the work of Scituate artists from the past. The current home, built on the foundation of the original, gained its fame in the 19th century through the poetry of Samuel Woodworth, whose work "The Old Oaken Bucket" has been translated into dozens of languages. Today, the Scituate Historical Society is working to bring the homestead back to its former glory, with a continued restoration plan in place for its interior and exterior, and wonderful possibilities for its landscaping.

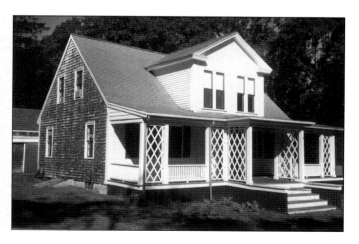

Down the street, the Stockbridge Gristmill across from Old Oaken Bucket Pond is undergoing its own renaissance. Inoperable for more than a decade, the 17th-century mill has seen two full years of preservation activity. A matching grant from the Society for the Preservation of Old Mills helped pay for the reshingling of two sides of the mill, repairs to rotted sills, and the replacement of a missing cornerpost, shown here. Volunteer painters from the Plymouth County Sheriff's Department touched up the red trim around the building, and Town Meeting appropriated funds to repair the sluice gate on the pond. A matching grant from the National Trust for Historic Preservation helped fund a thorough survey of the structure by a qualified millwright in January 2002. With the results of that survey in hand, the Scituate Historical Society is now looking forward to its ultimate goal of bringing the mill back to working condition and reopening it as a historic attraction.

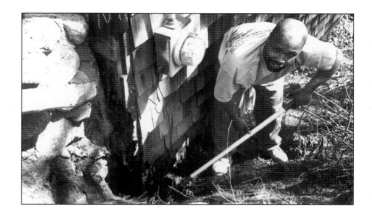

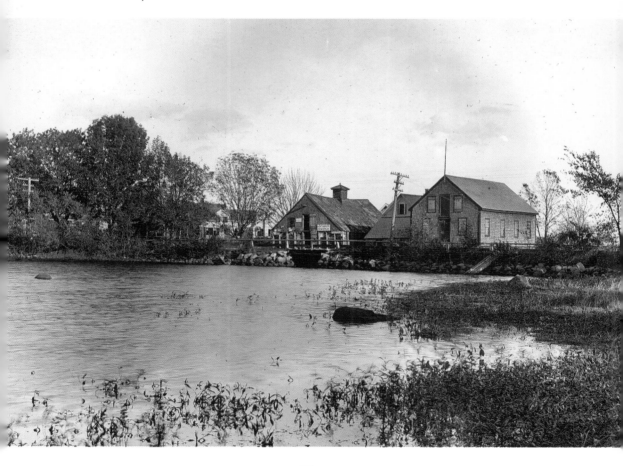

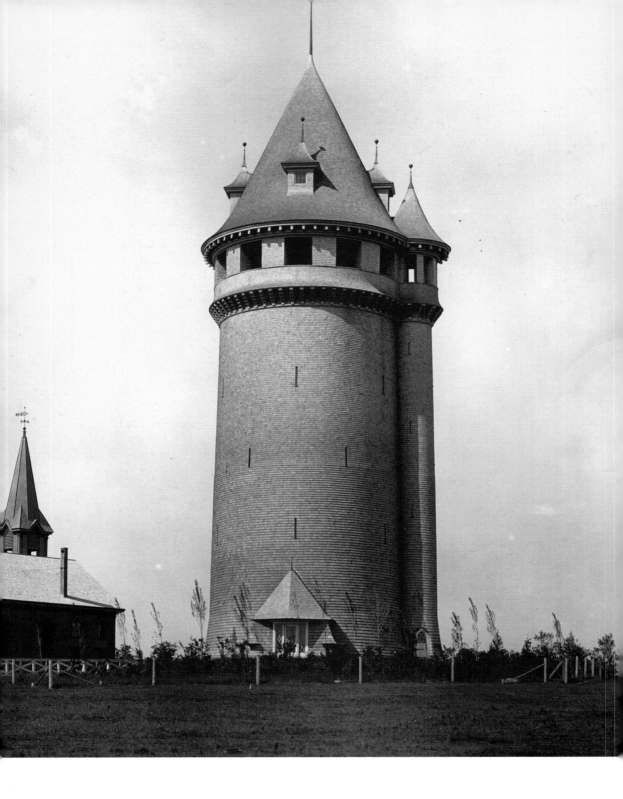

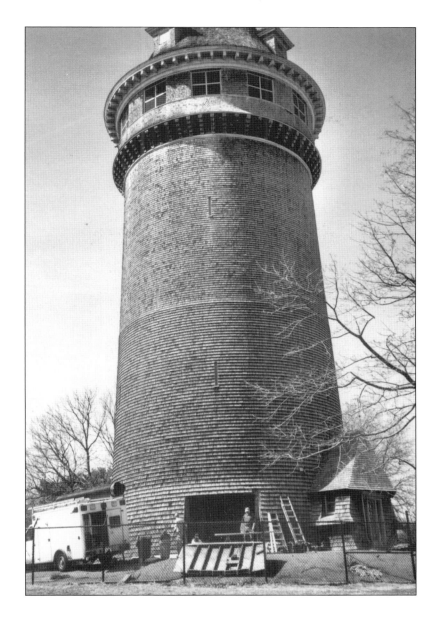

Tom Lawson's tower has seen better days. One hundred years old in 2002, the wooden structure itself is in good shape—solidly built, like everything else that Lawson's mind brought to construction in connection with his Dreamwold estate. A structural analysis, however, determined that the freestanding steel water tank inside the tower was failing, corroding to a dangerous point. With the safety of its visitors in mind, the Scituate Historical Society closed the tower to the public in 2000. Since that time, several waves of preservation work have taken place. The 10 bells at the top of the tower have been removed for refurbishing and storage to Cincinnati, Ohio, and now await the reconstruction of the frame on which they have hung since 1902. In March 2002, contractor Dana Green and his crew cut a door into the side of the tower to facilitate the removal of the steel tank in small sections. If all goes as planned, Scituate will hear the bells once again as it has in the past and may even see a totally new, innovative museum experience. Lawson Tower may have seen better days, but even better days than those past are ahead.

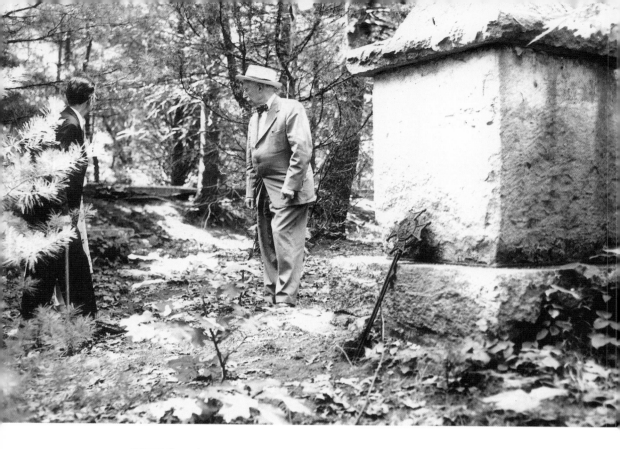

When the rumor of the existence of Chief Justice William Cushing's burial site reached newspaperman Willard Da Lue, he decided to do his best to track down its exact location. With friend Mert Coleman, he walked the length of Neal Gate Street, knocking on doors to find clues. Finally, one woman said

that she had never seen it but that her husband and children had. It was, she said, behind her house in the woods. Creeping through the tangled undergrowth, they scaled a small wooded hill until they reached its apex. There, surrounded by a square wall of granite, rested the Cushing family burial plot. They could hardly believe that the burial site of a member of the first U.S. Supreme Court could be so forgotten by time. That has all changed, however. In September 1955, the Scituate Historical Society passed the deed of the burial plot over to the state of Massachusetts, establishing Cushing Memorial Park at the time as the smallest state park in the country. In November 2000, Massachusetts Supreme Court Chief Justice Margaret Marshall visited the park, leading a clean-up effort of the site and planting a tree in memory of Chief Justice Cushing.

Another familiar landmark with which the Scituate Historical Society has been involved has been the Lawson Gates on Branch Street. Known as the farm gates by Tom Lawson's hired hands, the site is now the entrance to Bossy Lane and Manor Road. Weighed upon by time, the wooden gates have begun to show some serious signs of rot. As with several other historic sites in town, the gates are owned by the town of Scituate, and the historical society takes care of their maintenance and preservation. Contractor Dana Green rebuilt one of the main posts in 1999, with the rest to follow in a phased plan in coming years.

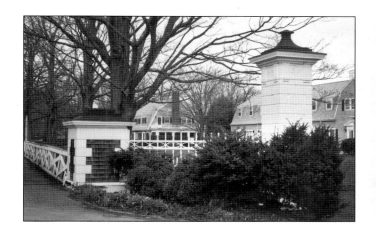

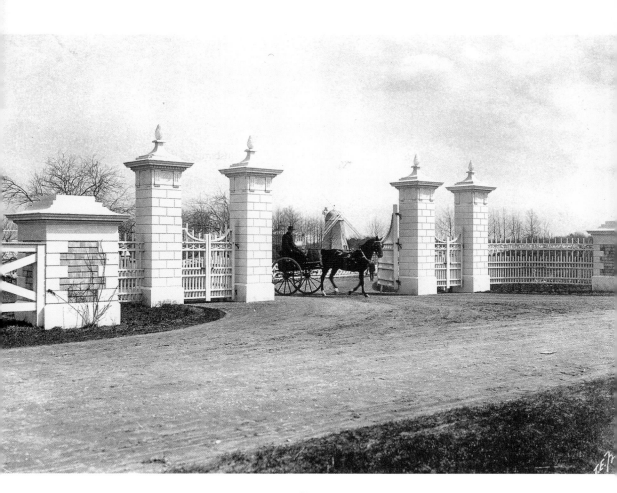

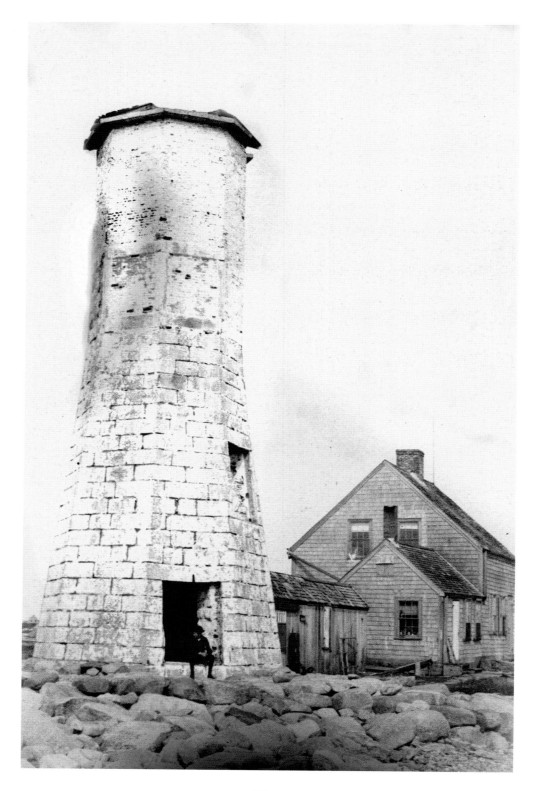

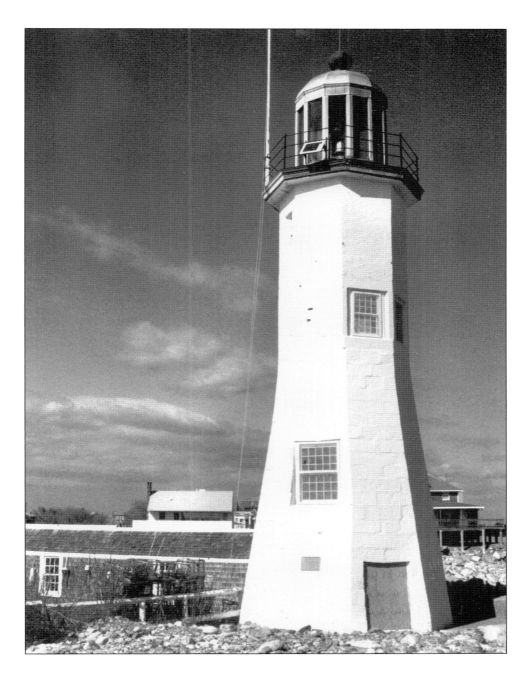

Scituate Lighthouse, built in 1811, still stands strong after nearly 200 years. The year 2001 marked a banner year for the site, as the society opened its new runway exhibit between the tower and the house. More than 25 donors paid $250 apiece for the society to design and mount graphic display panels depicting scenes from the lighthouse's past, from legend of the Bates sisters to the wreck of the *Etrusco* and more. A generous late donation funded the installation of a sound system as well. To complement the new exhibit, the historical society published and released *The Scituate Lighthouse Guidebook,* a guide to the history, site, and grounds of the town's most recognizable landmark.

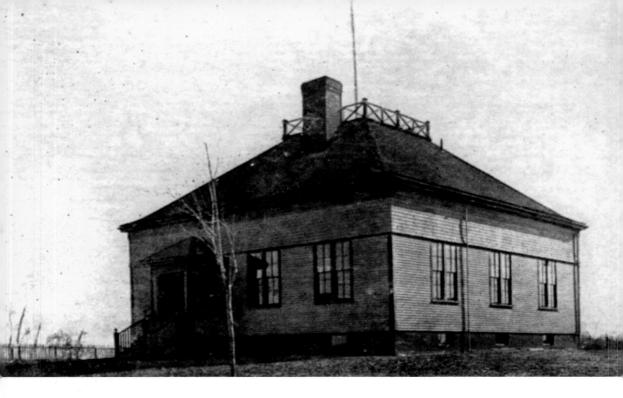

The walls of the town's first high school still ring with echoes of recitations and class songs performed at graduation exercises in years past. Built in 1893 and moved to its current site on Cudworth Road in 1919, the Little Red Schoolhouse, or Kathleen Laidlaw Historical Center, became the Scituate Historical Society's administrative headquarters in 1984, sold to the society by the town of Scituate that year for $1. Visitors from around the country researching family genealogies and early American history have perused the society's book collections throughout the years. Several small, rotating exhibits on historic costumes and other items from the society's collection have been displayed as well.

On Country Way stands the proud home of George W. Perry Post No. 31, Grand Army of the Republic. The restoration of Scituate's Grand Army Hall, once home to groups as diverse as barbershop quartets and Irish step dancers, has been a major preservation project of the historical society. The project has been taken in several phases—sill repair, main floor repair, kitchen layout, and so on. Each year has seen significant progress in the society's quest to make the Grand Army Hall a gathering place for the local community. Several artifacts were left behind by the men of the Grand Army of the Republic, such as a bayonet found jammed behind a wall and *c.* 1900 dance tickets found in a desk in the attic. The historical society has even published a quarterly newsletter on the building's story, *News From the Post,* covering both the site's restoration and tales from its past.

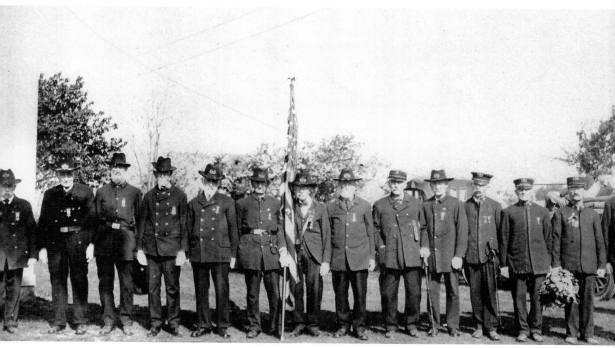

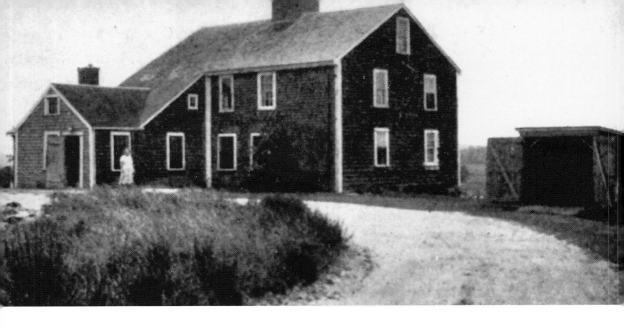

With miles of coastline stretching from the Scituate–Marshfield border on Humarock to the Glades, Scituate will always be known for its association with the sea. Shipbuilders along the North River and in Scituate Harbor constructed more than 1,000 vessels of significant tonnage between the 1690s and 1870. The Massachusetts Humane Society constructed one of its first three houses of refuge at the base of Third Cliff in 1787, and Irish mossers have spent more than a century and a half making their livings on the water. Sea captains found Scituate to be a convenient home, as Capt. Benjamin James found in this 1739 house on the Driftway.

This house is now the Scituate Maritime & Irish Mossing Museum. Purchased by the Scituate Historical Society in 1995, the building has been thoroughly restored both inside and out and today stands out as one of the most dynamic small museums on the South Shore. With six exhibit rooms, the museum covers many stories of Scituate and the sea, from shipbuilding and shipwrecks to lifesaving and lighthouses, and more. During the spring of 2002, the historical society arranged an international partnership with the Isles of Scilly Museum in England to display artifacts from the wreck of the *Thomas W. Lawson,* the world's only seven-masted schooner, lost in a gale on Friday, December 13, 1907. Designed by Scituate resident Pam Martell, the museum has become famous for its originality and innovative programming.

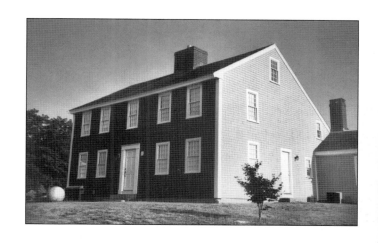

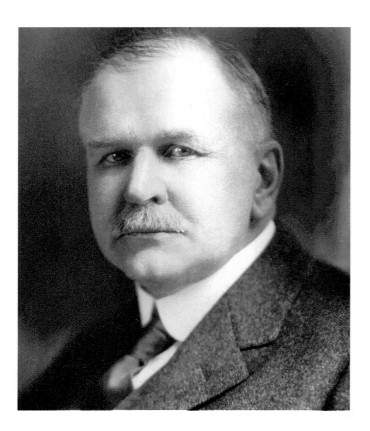

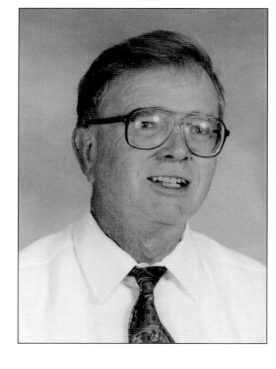

From the time of its founding in 1916 through the beginning of the 21st century, the Scituate Historical Society has been blessed with strong leadership, dedicated volunteers, and long-lasting municipal support. In 85 years, the society has had just nine presidents: Silas Pierce (1916–1922, above), Harvey Hunter Pratt (1922–1925), Thomas Hatch Farmer (1925–1935), Nathaniel Tilden (1935–1940), Isabelle Nason (1940–1945), Wilmot Brown (1945–1963), Frank Merton Colman (1963–1966), Kathleen Laidlaw (1966–1996), and David Ball (1996–2002, right). Steady growth from the 1960s forward has built the Scituate Historical Society into one of the largest organizations of its type in the country. As long as the people of Scituate wish to preserve their history, the historical society will strive to fulfill its mission to "preserve the antiquities of Scituate and those municipalities that were anciently a part of the town."

ACKNOWLEDGMENTS

The authors would like to thank George and Carolyn Bearce, Les Molyneaux, Carol Miles, Midge Lawlor, Steve Spear, and Susan Lovering. David Corbin would also like to thank his father, Robert James Corbin, whom he credits with instilling in him at a young age a love of history; Willard Litchfield (1900–1982) for all those stories of old Scituate as only he could tell them; Mrs. Duncan Bates Todd, because of whose countless hours of research at the Scituate Historical Society the entire town is that much richer; and David Dixon, whose past research and latest effort, *Two Scituates: Development and Division in a Summer Resort, 1870–1900,* have shed light on a neglected subject and have been major sources for this book. John Galluzzo would like to thank David Ball and Fred Freitas for taking a chance on him what seems like a million years ago, Profs. Franklin Wickwire and R. Dean Ware for helping the history beast within him find its way out, Amy Sutton for guidance through four titles, and Susan Phippen for inspiration, leadership, direction, and, most importantly, friendship.

To the membership of the Scituate Historical Society, from 1917 to 2002—so much has been accomplished, yet there is still so much to do. We thank you all.

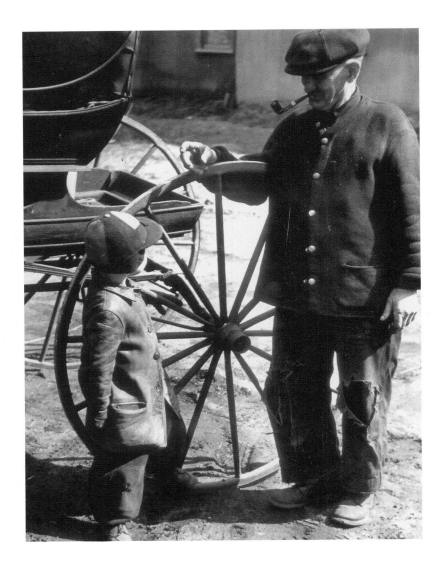

The Scituate Historical Society exists for the purpose of educating all who seek knowledge of the history of the town and people of Scituate and those municipalities that were anciently a part of the town through the publication of printed material, public lectures, thoroughly descriptive tours of Scituate's historic sites, and the continued growth of a volunteer-staffed and free-to-the-public historical and genealogical library, with a strong interest in instilling a sense of stewardship of the town's history in schoolchildren. As stewards of the town's most precious historic landmarks, the society constantly searches for new, innovative, and effective means of raising funds for the continuing preservation efforts at each of the nine sites with which it is associated, with particular emphasis placed on the restoration of the Stockbridge Gristmill, the completion of the George W. Perry Post No. 31, Grand Army Hall Restoration Project, and the overall future financial stability of the organization. The society acts as a leader and partner in the historical preservation field through collaborative efforts with local, state, national, and international historical, fraternal, municipal, and educational organizations. The society also reaches out to the people of the community and region for input and works with the local chamber of commerce and regional and state tourism councils to increase tourism to the South Shore of Boston, promoting and celebrating the cultural diversity of Scituate and Plymouth County, Massachusetts.